Rembrandt

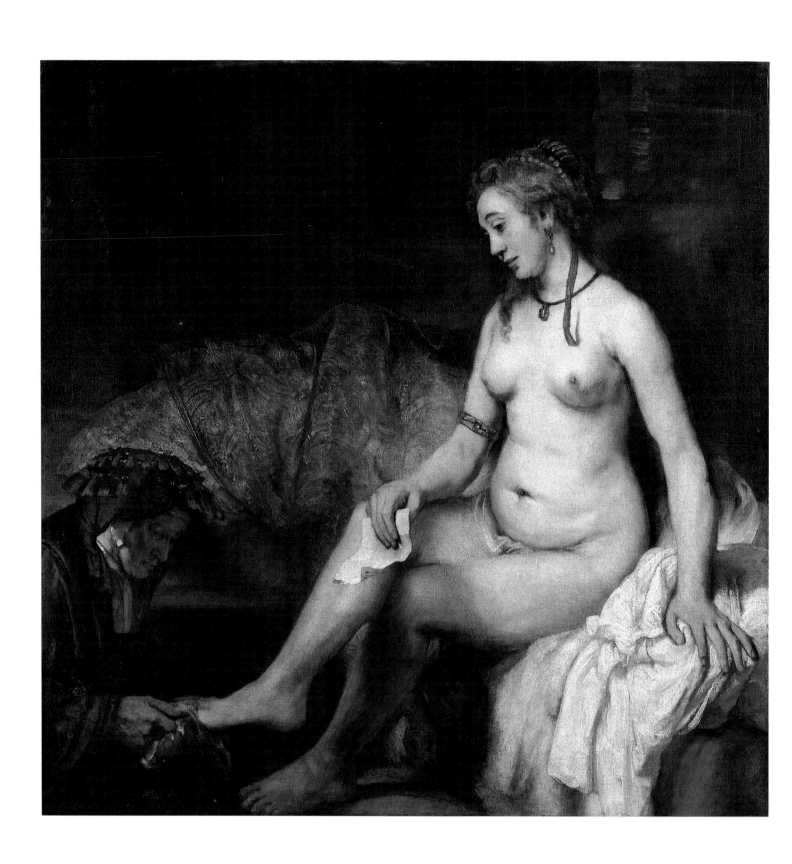

Michael Bockemühl

REMBRANDT

1606–1669

The Mystery of the Revealed Form

Benedikt Taschen

FRONT COVER:
The Militia Company of Captain Frans Banning Cocq
(the so-called *Night Watch*), detail, 1642
Oil on canvas, 363 x 437 cm
Amsterdam, Rijksmuseum

PAGE 1:
*Self-portrait from Front, with Cap, c.*1634
Etching, sole state, 50 x 44 cm
Amsterdam, Rijksmuseum

FRONTISPIECE:
Bathsheba with King David's Letter, 1654
Oil on canvas, 142 x 142 cm
Paris, Musée du Louvre

© 1992 Benedikt Taschen Verlag GmbH
Hohenzollernring 53, D-5000 Köln 1
Edited and produced by Brigitte Hilmer, Basle
Cover design by Peter Feierabend, Berlin
Picture research by Frigga Finkentey, Cologne
English translation by Michael Claridge, Bamberg
Printed in Germany
ISBN 3–8228–0559–9
GB

Contents

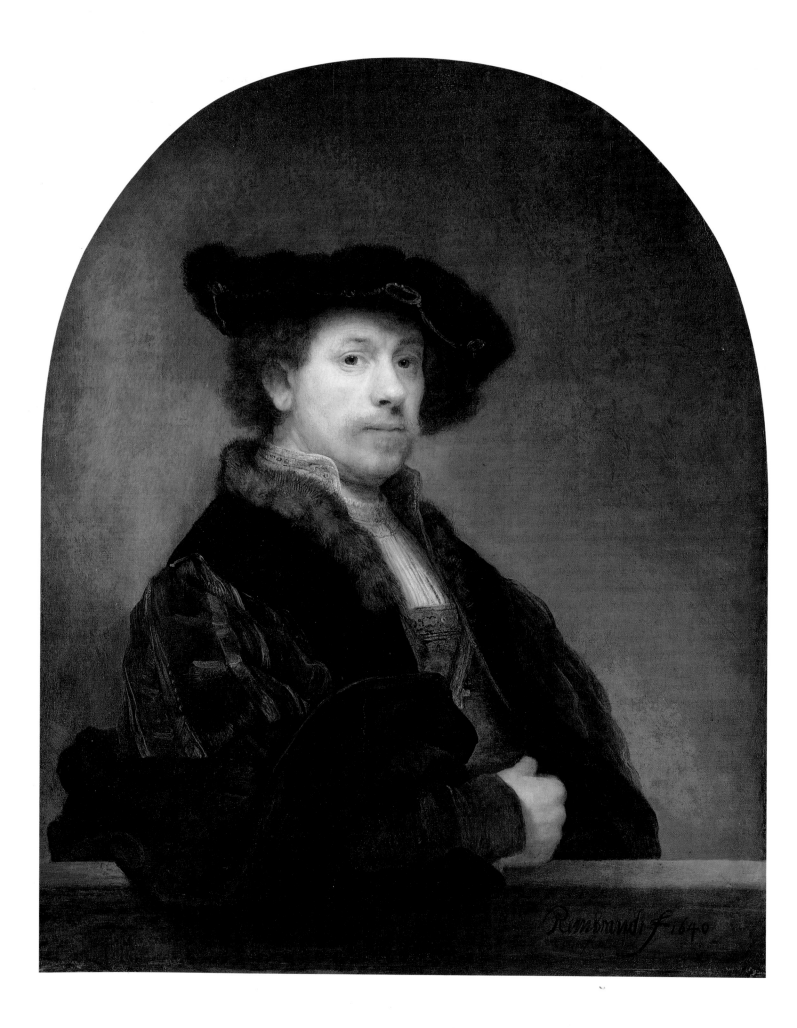

Rembrandt – a never-ending experience

Raising his head, the young man turns it briefly to one side (p. 8). His tangled, flying hair falls over his brow and the nape of his neck. His soft lips are slightly opened, his eyebrows raised. The movement that he makes brings his face into the ray of light falling over his left shoulder. For a moment, his cheek and the tip of his nose are lit up above his white collar. The shaded eyes meet those of the observer, without fixing themselves upon them, as if they had become aware of something, as if they were searching for something. The open countenance appears lost in thought, given up to the world around it. The very small format nonetheless reveals a highly effective interplay between the light and dark elements. The application of paint is varied, carefully smoothed transitions being visible alongside spontaneous brushstrokes, scrapemarks, smudges and dabs.

Dressed in furs, brocade and velvet, a man rests his forearm on a barrier, in such a manner that his elbow with its sumptuously heavy stole projects forwards (p. 6). The face, in half-profile under the sweeping cap, reveals a hint of noble melancholy. Its gaze is directed towards the observer, yet keeps to itself. The precisely composed figure stands out against the neutral, predominantly bright background as an individual, present form. The posture of the portrait's subject and the perfection of the manner of painting call to mind the work of other great artists, such as that of Titian or Raphael. "Rembrandt f. 1640", written in a broad hand, may be read on the barrier to the right.

The old man wears a gown and cap of dark velvet of a reddish-violet hue broken towards brown (p. 10). His hands are folded in front of his body, his facial features composed. His gaze, resting upon the observer, notices him, meets his eyes, communicates with him, enquiring. Resignation and expectation, scepticism and familiarity, lack of fulfilment and contentment with his lot are present in equal measure in the tranquil countenance. His brow and the cap's white border are lit up against the background, which disappears to the right into a darkness of immeasurable depth. The figure appears near, and yet also unapproachably distant. Its atmospheric surroundings pull the observer in. The lines delineating the eyes, the bridge of the nose, and the side curls are finely distinguished; in contrast, the surrounding contours disappear in such a manner as to give the impression of incompleteness. The colour of the garment is simultaneously comprehensible and incomprehensible: it can be defined – and yet defies definition. As with the fulness of expression contained in this figure, so with the colours and forms: they, too, do not appear here as something enduring. That which creates such a vivid impression upon the observer escapes any defining concept, going beyond the realm of words. The open structure, with its almost uncompleted appearance, nevertheless asserts itself as one that is finished, one in which the observer directly and completely participates.

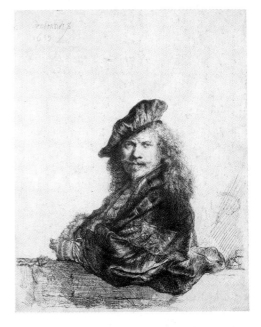

Self-portrait Leaning on a Stone Sill, 1639
Etching, 2nd state, 20.7 x 16.4 cm
Amsterdam, Rijksmuseum

Self-portrait, 1640
Oil on canvas, 102 x 80 cm
London, The National Gallery

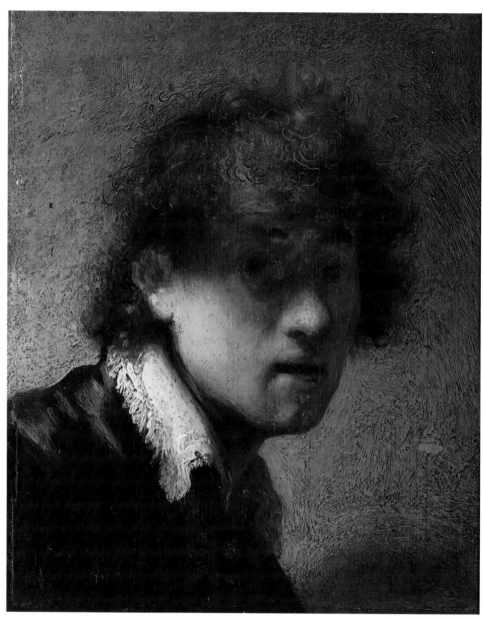

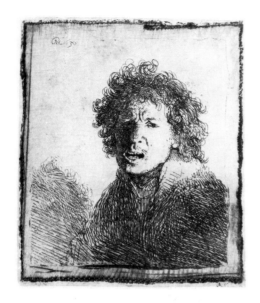

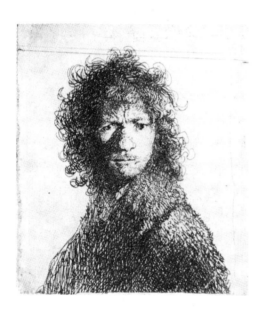

Self-portrait, 1629
Oil on panel, 15.5 x 12.7 cm
Munich, Alte Pinakothek

ILLUSTRATION, UPPER LEFT:
Self-portrait Open-mouthed, 1630
Etching, 2nd state, 7.2 x 6.1 cm
Amsterdam, Rijksmuseum,
Rijksprentenkabinet

ILLUSTRATION, LOWER LEFT:
Self-portrait with Knitted Brows, 1630
Etching, 1st state, 8.3 x 7.2 cm
Amsterdam, Rijksmuseum,
Rijksprentenkabinet

Three figures, three styles, three worlds. The change in Rembrandt's paint-
ing, taking place over a creative span of forty-four years, is one of an extremely
far-reaching nature. The richest display of unparalleled artistry in painting and
virtuosity results directly from what are sometimes almost clumsy or wild be-
ginnings – although a closer look reveals them to be most eloquent – until a
pictorial form finally develops, the enigma of which remains unsolved to this
day. The succession of paintings, together with the no less important etchings,
point to a restless searching. Each picture, every version of the same picture,
represents a new experiment, referring back and looking forward, with new
qualities constantly coming to light. The great abundance of freehand drawings
provides evidence of unrestrained creative powers allowing of no submission to
any step-by-step process. This development nevertheless constitutes a unity:
from beginning to end, Rembrandt was to remain true to those tasks and mo-
tifs which he had originally adopted. In retrospect, this development can be
seen as following a consistent course.

This becomes particularly clear when one examines different versions of the
same subject-matter. For example, the seventeen different sketches and arrange-

ments of *Simeon with the Christ Child* (The Presentation of Jesus in the Temple, Luke 2, pp. 21, 30, 31, 78) alone offer a succession of new versions.

Furthermore, the series of self-portraits – surely not the result of the artist's later occasional financial straits preventing him from coming up with the fee for a model – is without equal. These pictures should not be seen merely as a portrayal of Rembrandt in the various stages of his life, nor do they simply reveal the variety of possibilities by means of which he could convey facial expression – although he did experiment with this in impressive ways as a young man (pp. 8, 9). The series is still capable of causing astonishment as one of the most radical self-portrayals in the world of painting. The portraits referred to above include one of his earliest, one from the middle years of his life, and one of the last pictures that he was to produce. On looking at the pictures for the first time, the observer is immediately struck by the diversity of this personality through the manner in which the artist depicts himself as a young man, presents himself in mid-life, and achieves the effect of a personal contact in the final year of his life. If one wishes to get closer to Rembrandt's art, however, it is more important to examine the pictorial qualities by means of which these differentiated inner qualities first become comprehensible.

These portraits give us an insight into a career which outwardly consisted principally of constant work with no spectacular incidents. Rembrandt lived in Leiden during his apprenticeship and initial years as an artist, thereafter spending the rest of his life in Amsterdam; unlike other artists, he never travelled to Italy. The climax of his civic prestige was overtaken by the death of his first wife, Saskia van Uylenburgh, in 1642, while legal disputes and a bankruptcy created difficulties for him. However, he was enabled to enjoy a number of years of undisturbed creative work thereafter through Hendrickje Stoffels, his mistress, and his son, Titus. He lived in a secluded manner, but not in isolation, and received commissions from cultured friends and collectors.

After times of mystification, Rembrandt's circumstances and his work have been the subject of extensive research. The conditions under which his pictures were produced, his clients, those depicted in his portraits – all these have been investigated; his subject-matter has been related to the art of that time; his painting technique has been reconstructed. Most important, those works originating from Rembrandt's own hand have finally been separated from what soon became an equally high number of pictures attributed to him – for whatever reason – and accepted as such until very recently. The fact that questions still remain, among them those in the field of motif interpretation, for which research has failed to find an answer does not suffice to explain the present interest in his art, something which was not sparked off until the beginning of the 20th century and has yet to die down. The latest knowledge made accessible by the 20th-century art world appears to have served merely to heighten, rather than diminish, this fascination with Rembrandt's painting.

Rembrandt's complete works have a characteristic nature all their own, yet it was only in the course of his development that the effect of his pictures, so totally his own, unique in the history of art, would take on such a nature. It is those qualities of the later works requiring the observer's active involvement that are still to be discovered today.

It is the intention of this little book to point to the effect upon the observer of Rembrandt's painting. What follows will concentrate accordingly upon the pictures. A process of selection proved necessary; nor was it possible to embark upon any comparisons with other painters. If attention is to be focussed upon the qualities in question – albeit only in broad outline – then there is space here to go into only a few examples in depth. An attempt will be made to follow

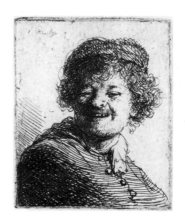

Self-portrait with Cap, Laughing, 1630
Etching, 3rd state, 5.0 x 4.4 cm
Amsterdam, Rijksmuseum,
Rijksprentenkabinet

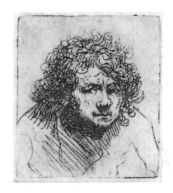

Self-portrait, Bent Forwards, c. 1628
Etching, 3rd state, 4.3 x 4.0 cm
Amsterdam, Rijksmuseum
Rijksprentenkabinet

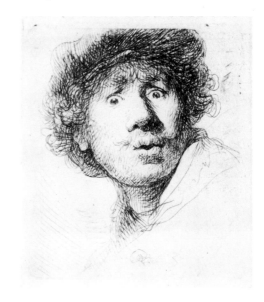

Self-portrait with Wide-open Eyes, 1630
Etching, sole state, 5.1 x 4.6 cm
Amsterdam, Rijksmuseum,
Rijksprentenkabinet

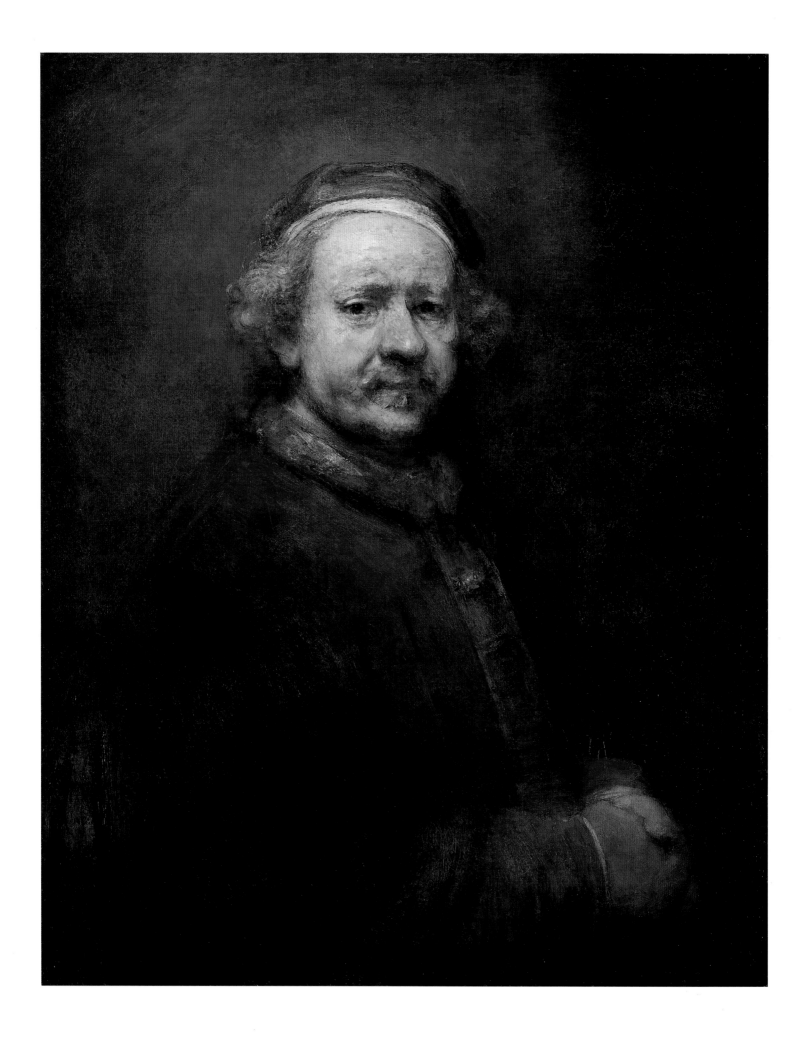

Rembrandt's development via the observation of his pictures. Suggestions will be put forward in this context with regard to the reader's own observation of the pictures – after all, if it really is a question here of observation, then nothing can replace the experience gained when the observer himself sees a picture.

A division into three parts emerges here, one which might appear to be behind the selection of the self-portraits considered above. Reality is far more complicated, however. Many phases can be distinguished, but it is almost impossible to separate them from each other. One characteristic merges with the next. Individual observations can be used merely as an opportunity to notice the change taking place in an overall context, the analysis of which would have to remain ever in question.

In interpreting a picture as a representation of something, one usually fails to notice its effect upon the observer from a purely visual point of view. However, an attempt to follow Rembrandt's artistic path by means of an observation of his pictures cannot afford to pass up an understanding of the subject(s) portrayed in those pictures. If the observational qualities of Rembrandt's pictures are to be clearly grasped, it must first be quite plain to what extent the purely visual elements in a picture – the depiction of a particular event, for example – convey to the observer the underlying meaning of the work in question. It is only through a precise and thorough examination of the concrete details, together with a reflection as to what it is that makes one or the other feature recognizable, that the pictorial qualities themselves can be appreciated – not in some general, unfocussed manner but each in the quite individual form in which it is effective. Accordingly, the following examination will take a course such as will first go into Rembrandt's manner of representation, in particular the structural conception of his pictorial scenes. This in turn will gradually render essential a direct discussion of the pictures' purely visual qualities. A mandatory passage through those elements which can be appreciated in the pictures will be necessary to clear the observer's gaze, so that he can then see with the same awareness where it is only a question of seeing – namely, in the later work.

The development that Rembrandt's paintings undergo is no path from the incomplete to the perfect, from the approximate to the precise, from the sketched to the accomplished; nor does it follow the reverse course. It completely converts everything comprehended in the picture – the symbols, the narrations, the figures, the spatial dimension, the light, even the temporal event – into the observational reality of the picture: in short, it changes comprehension itself into vision. This art thereby touches upon the fundamental certainties of recognition. The experience of Rembrandt's art appears more relevant than ever before. It can reveal itself today as a never-ending challenge to make oneself conscious of the chances offered by the observational act. Rembrandt – a never-ending experience.

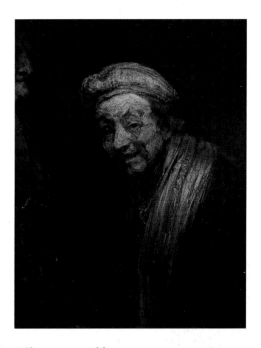

Self-portrait, c. 1668
Oil on canvas, 82.5 x 65 cm
Cologne, Wallraf-Richartz-Museum

Self-portrait, 1669
Oil on canvas, 86 x 70.5 cm
London, The National Gallery

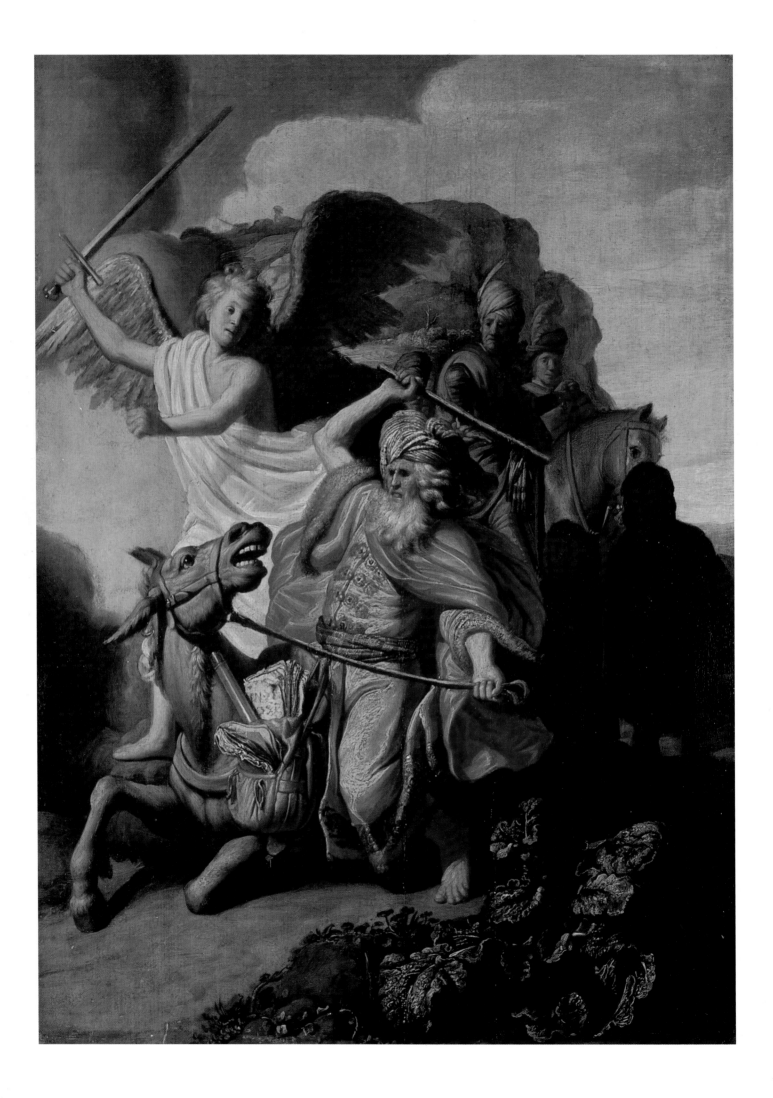

Rembrandt the thinker:
The structural conception of Rembrandt's early pictures

Goethe gave his brief description of an etching, *The Good Samaritan* (p. 36), the title "Rembrandt the thinker", thereby characterizing with a word Rembrandt's early period of creativity. After only a year's apprenticeship with van Swanenburgh, the painter, and half a year's study with Pieter Lastman in Amsterdam, the 19-year-old Rembrandt set up on his own in Leiden, his birthplace, in a studio which he shared with Jan Lievens, his friend and colleague, who was a year younger. The reputation of the unconventional young artists spread rapidly. They were honoured with a visit from, among others, Constantijn Huygens, the secretary of the governor, Prince Frederik Hendrik, who was later to become an important patron for Rembrandt. Co-operation with Hendrik Uylenburgh, the Amsterdam art dealer, developed. Commissions from this direction multiplied, and by 1630 Rembrandt was working predominantly in the up-and-coming city. In 1633, the year of the previously mentioned etching, he became engaged to Saskia van Uylenburgh, the art dealer's niece.

Rembrandt almost casually added a few more figures to the scene illustrated in *The Good Samaritan*, despite their being unmentioned in the Gospel account. The crucial element in Goethe's observation consists in the fact that he sees not only the principal characters but also these minor figures as all bound up in a closely woven plot structure, one from which the depicted event can be completely reconstructed as a contemporary situation. Goethe demonstrates in his description how a dramatic plot structure is created in the static pictorial scene through the constellation of the figures, their attitudes and expressions, and acknowledges the structural conception of this artist's pictures in "Rembrandt the thinker". Questions of structural conception within his pictures were to accompany Rembrandt's work to the end; in his early creative period, however, his attention was devoted exclusively to them.

The Martyrdom of St.Stephen (p. 14) is Rembrandt's earliest extant painting. The victim of the stoning is hemmed in by many figures making vigorous, extended movements. As if the close-packed nature of the crowd were not enough, the artist has squeezed the faces of background figures into every small space left by the foreground figures. Various forms, likewise present at the spectacle, are portrayed close to the central group. The whole picture is characterized by the turbulence of a scene filled with many figures, along with the dramatic expression of tumult, violence and pain. Although this is only his first picture, the young painter is already presenting himself in a profession which was considered at that time to be the hardest and was correspondingly highly regarded. It was a question here of whether the artist was capable of mastering not only every possibility of spatial depiction – landscape and architecture – but also, equally, animal and human anatomy in every conceivable posture.

Christ Driving the Money-changers from the Temple, 1626
Oil on panel, 43.1 x 32 cm
Moscow, Pushkin Museum

The Ass of Balaam Balking before the Angel, 1626
Oil on panel, 63.2 x 46.5 cm
Paris, Musée Cognacq-Jay

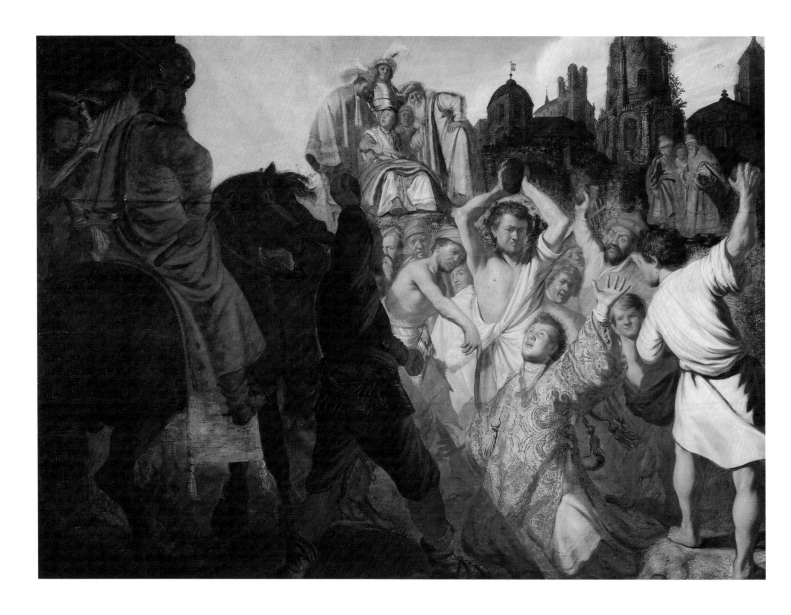

The Martyrdom of St. Stephen, 1625
Oil on panel, 89.5 x 123.6 cm
Lyons, Musée des Beaux-Arts de Lyon

wever, the "history painter" was judged primarily according to the degree of success with which he used facial expression and gesture to characterize the particular emotional mien of the figures as stipulated by the event in question – what was called at the time the "passions".

It is in accordance with this that a further work from the early period, *Christ Driving the Money-changers from the Temple* (p. 13), is restricted to the passions of the figures, to the expression of anger, terror, pain and avarice. These qualities of expression are emphasized in an extremely clear manner, as a result of which some of the expressions have taken on a grimace-like appearance.

The same extreme effect may be observed of the passions in the scene entitled *The Ass of Balaam Balking before the Angel* (p. 12). The painting is concerned with the Old Testament account (Numbers 22) in which the prophet Balaam is instructed by Balak, King of the Moabites, to curse the Israelites. While on his way to the King, Balaam's path is blocked by the angel of the Lord, who is noticed by the prophet's donkey, but not by the man. When Balaam attempts to drive on his donkey with blows, the hesitating beast is given the gift of speech. The Lord opens Balaam's eyes, and he perceives the angel. Instead of cursing the chosen people, he blesses them and announces future victories for them.

Rembrandt took over the scenery to a considerable extent from a picture by Pieter Lastman. However, the gestures in his own painting are much more forceful: the hand holding the stick is raised to a more threatening position, the donkey has pulled her head further back, and her jaws are open wider. The an-

gel with the uplifted sword has been moved right up to the raging prophet, as are Balaam's companions, who are observing the scene. The movements of the figures cover the entire picture. The violent gesture of the raised arm and the features of the prophet, contorted with the strain, remove all doubt with regard to whether a blow will in fact be struck and where it will land. In the same way, the angel's gesture communicates the fact that his sword, once set in motion, is capable of parrying Balaam's stick and thereby protecting the donkey from the unjust blow. Lastman's picture portrays the point in the scene where the animal speaks, thus depicting the actual occurrence of the miracle. Rembrandt intensifies the situation further by characterizing this point in time as the moment in which the highest possible unfolding of movement takes place.

A general survey of the scenic creations from the Leiden years and the initial Amsterdam period produces the realization that almost all of Rembrandt's portrayals of events are conceived at the climax of their external action. This can be seen in the "histories" both from mythology, such as *The Abduction of Proserpine* (p. 25), and from the Bible, such as *Christ in the Storm on the Lake of Galilee* (p. 17). This principle is pushed to the extreme in the scenes *The Angel Stopping Abraham from Sacrificing Isaac to God* (p. 16) and *The Blinding of Samson* (p. 18). The intention of the artist in depicting the climax of external action can only be to achieve the utmost vividness in the presentation of the event; the observer is to become an eye-witness, and thereby directly experience the event for himself. In doing this, Rembrandt does not shy away from drastic motifs. In *The Sacrifice of Isaac*, the angel has seized Abraham's arm, which was already raised to kill his son. The old man is turning round in the utmost grief and terror; his hand has opened and the knife, intended for the exposed neck of his son, is falling to the ground. In *The Blinding of Samson* (p. 18), we are shown with agonizing meticulousness the manner in which a Philistine driving a dagger into the hero's eye causes the blood to spurt forth.

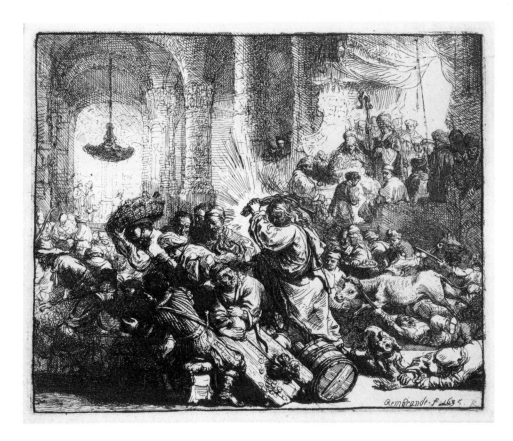

Christ Driving the Traders from the Temple, 1635
Etching, 1st state, 13.7 x 16.8 cm
Amsterdam, Rijksmuseum

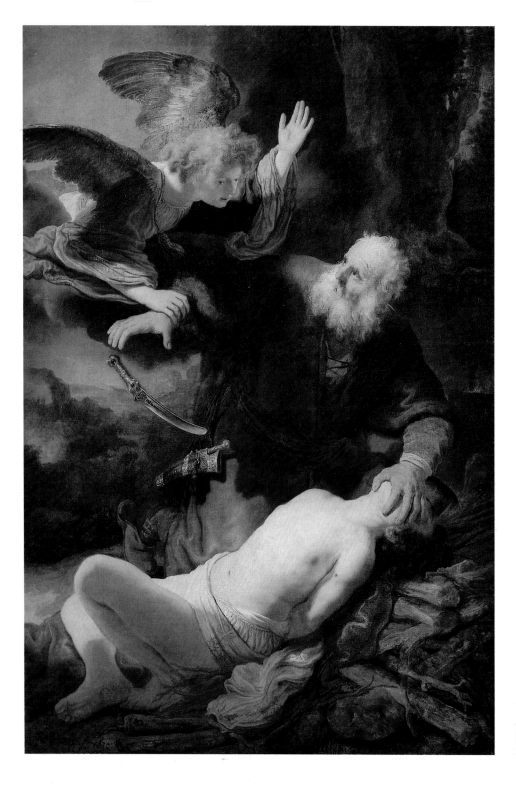

*The Angel Stopping Abraham from Sacrificing
Isaac to God,* 1635
Oil on canvas, 193.5 x 132.8 cm
St. Petersburg, Hermitage

Christ in the Storm on the Lake of Galilee, 1633
Oil on canvas, 160 x 128 cm
Boston, Isabella Stewart Gardner Museum

We are concerned in both of these cases with a violation of the static nature of the picture. An examination of the way in which knife and blood are depicted reveals that they can only be in free fall: the position of the knife makes no sense unless we understand it as in motion. The form taken by this motif of free fall compels the observer to imagine movement taking place. Yet a more protracted examination of the picture renders the actual motionlessness of the knife and of the drops of blood grotesque. They contradict the real course of events. And it is clear that this contradiction will become all the more striking, the longer the picture is studied. The drastic means through which Rembrandt wishes to render what is portrayed in the picture so emphatically comprehensible as motion, happening, action, simultaneously reveals the fact that the pic-

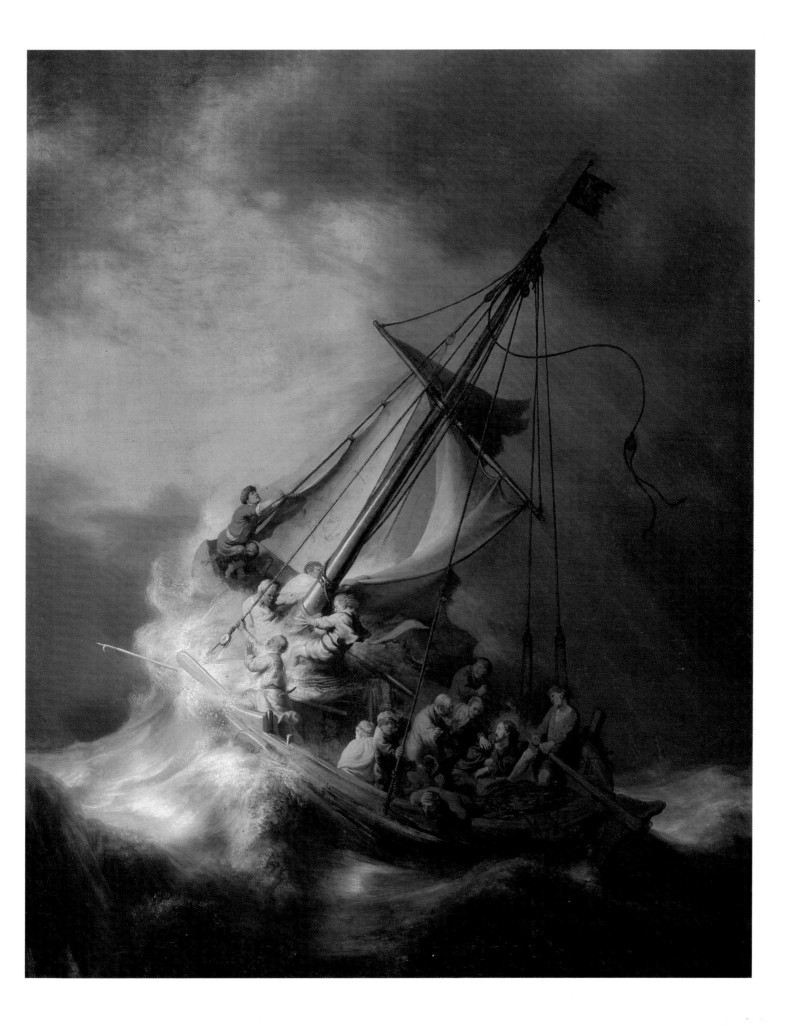

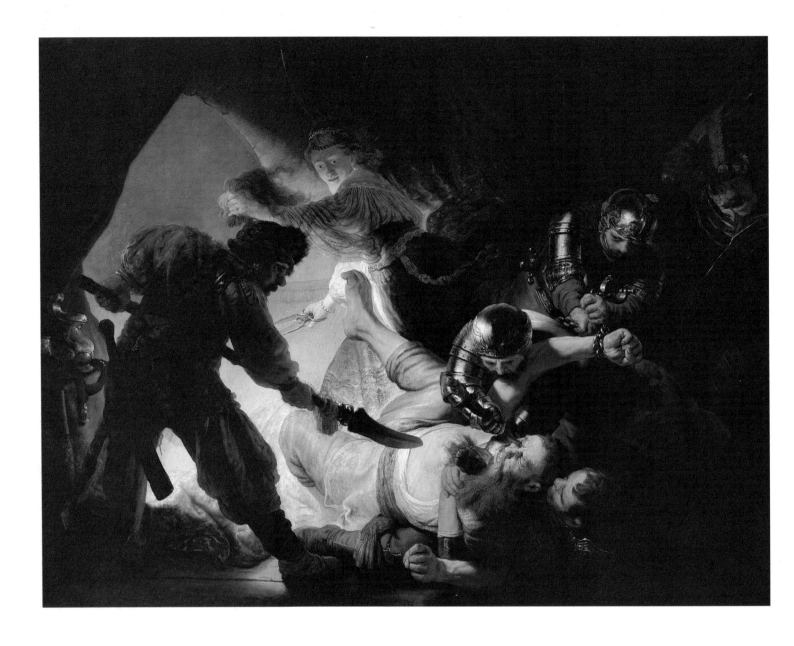

The Blinding of Samson, 1636
Oil on canvas, 206 x 276 cm
Frankfurt/M., Städelsches Kunstinstitut

Detail from *The Blinding of Samson*

ture can merely help the observer to *imagine* the intended course of events in his mind's eye; it cannot enable him to actually *see* them in the reality of the picture.

A limitation of the picture is indicated here, one which can be regarded as self-evident. Since the painted picture is naturally without movement, it would seem that the course of events depicted therein would necessarily belong to a different reality than that of the picture itself. This is one of the arguments put forward for regarding the pictorial world as merely appearance and distancing it from the reality of an event involving movement. By intensifying his scenes as far as the climax of the external action, the young Rembrandt is pushing at the limits of pictorial art. However, those scenes of his which are full of wild movement argue that he refuses to recognize these limits, that he will break through them – by force, if need be. It is instructive to see the painter beginning in his early work at precisely the point where the possibilities offered by painting end. He was nonetheless to hold for all of his creative life to the principle of depicting events and processes, always presenting them at their climax. This indicates one of the fundamental artistic problems with which he was to struggle unceasingly. It is important to stress the fundamental nature of this problem,

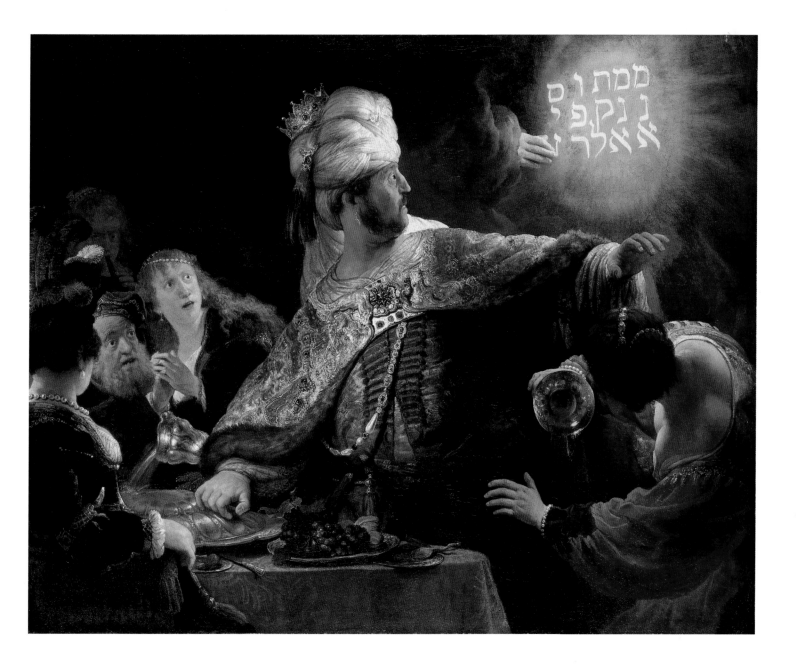

since we will observe in the following how Rembrandt was ultimately to re-
solve the apparently inevitable contradiction between the motionlessness of a
picture and the temporal nature of a dramatic event – with every consequence
both for the prior understanding characterized here of pictorial reality and for
observation itself.

The works cited above already demonstrate the first important signs in this
direction. The structural conception of these scenes does not limit the observer
solely to the here-and-now of a rapidly passing event. Other measures are added
to that previously mentioned of extreme climax: allusions are made to what has
gone before and what will follow.

The Blinding of Samson reveals other warriors in addition to the one who is
boring his dagger into Samson's eye. One of them lies under Samson, holding
him fast; another is fettering Samson's raised fist with a chain; a third, with
sword raised, is approaching from the rear to the right, mouth and eyes opened
wide; a fourth is holding his lance pointed at Samson, poised to stab should the
latter still possess the strength to resist despite the loss of his hair. Looking
back at Samson, Delilah is fleeing behind the man with the lance, holding in
her hands the scissors and the shock of hair which she has previously cut off.

The Feast of Belshazzar, c. 1635
Oil on canvas, 167 x 209 cm
London, The National Gallery

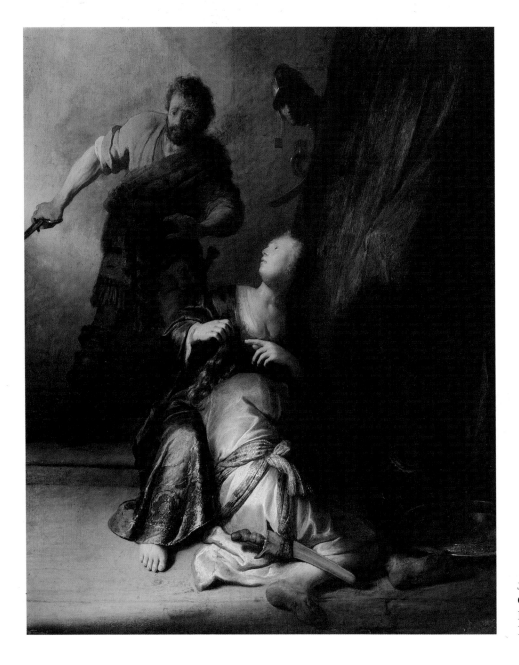

Samson Betrayed by Delilah, c. 1629/30
Oil on panel, 61.3 x 50.1 cm
Berlin, Gemäldegalerie, Staatliche Museen
Preußischer Kulturbesitz

Each figure contributes in its own way to the overall action at the moment of
the blinding. While it is true that Delilah is represented running away from
the scene, the fact that the treacherous mistress has cropped the hair of the
sleeping Samson beforehand is no longer left merely to the reconstruction ren-
dered by the observer's imagination: scissors and shock of hair are displayed in
the picture. This is made still more intelligible by the collective actions of the
warriors. We see one of them entering in a timorous manner; a second, who has
wrestled Samson to the ground; a third, shackling him; a fourth, striking home.
In order to be able to blind Samson, it was necessary for the warriors to force an
entry following the robbery of his hair, wrestle the weakened man to the floor,
fetter him and gouge out his eyes. Every one of the stages in this process is dis-
tributed among the individual figures. The figures reveal various stages in the
course of events. They do not indicate individually what is happening at the
precise moment when the blood spurts forth; rather, this form of temporal role-
distribution is used to illustrate the phases of the chain of events in the picture
itself. Rembrandt had already structured the motif of a step-by-step approach
in 1629 in an initial version of the Samson topic (p. 20).

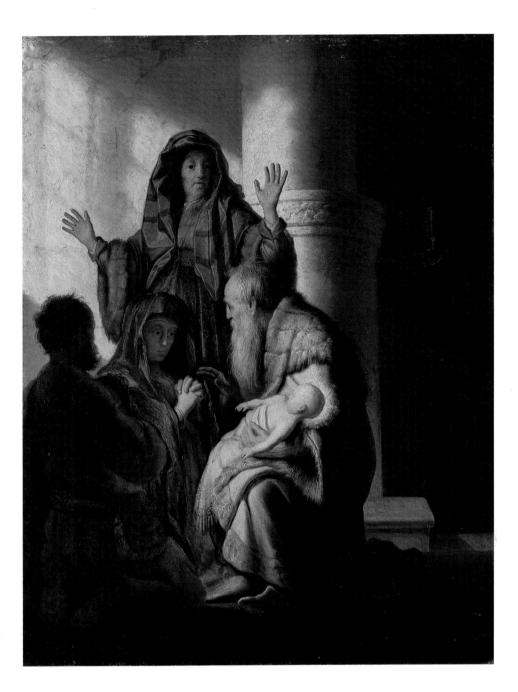

The Presentation of Jesus in the Temple, c. 1627/28
Oil on panel, 55.4 x 43.7 cm
Hamburg, Hamburger Kunsthalle

This structural conception serves partly to reconcile the events – at least, those preceding the brutal blow – with the fact that their portrayal in the picture is motionless. The reconstructing fantasy of the observer need not detach itself quite so far from that which is portrayed in the picture as is necessary with representations showing only a single moment in the sequence of events. Indeed, we can say that his fantasy can return again and again step by step to the picture so as to follow the sequence of events.

A particular role is played by the lance-wielding warrior in the right foreground. He is pausing for a moment, while everything else takes place around him. He is no less involved in the events than the other protagonists: he is keeping watch. However, this watch only becomes clear when one understands his posture as one of temporary motionlessness. His posture of temporary duration finds itself in unison for precisely this space of time with the motionlessness of its pictorial portrayal, without losing its sense of taking part in the action. This in turn points to a further element in the structural conception of Rembrandt's early pictures.

If the artist has free choice of subject-matter, then his choice says some-

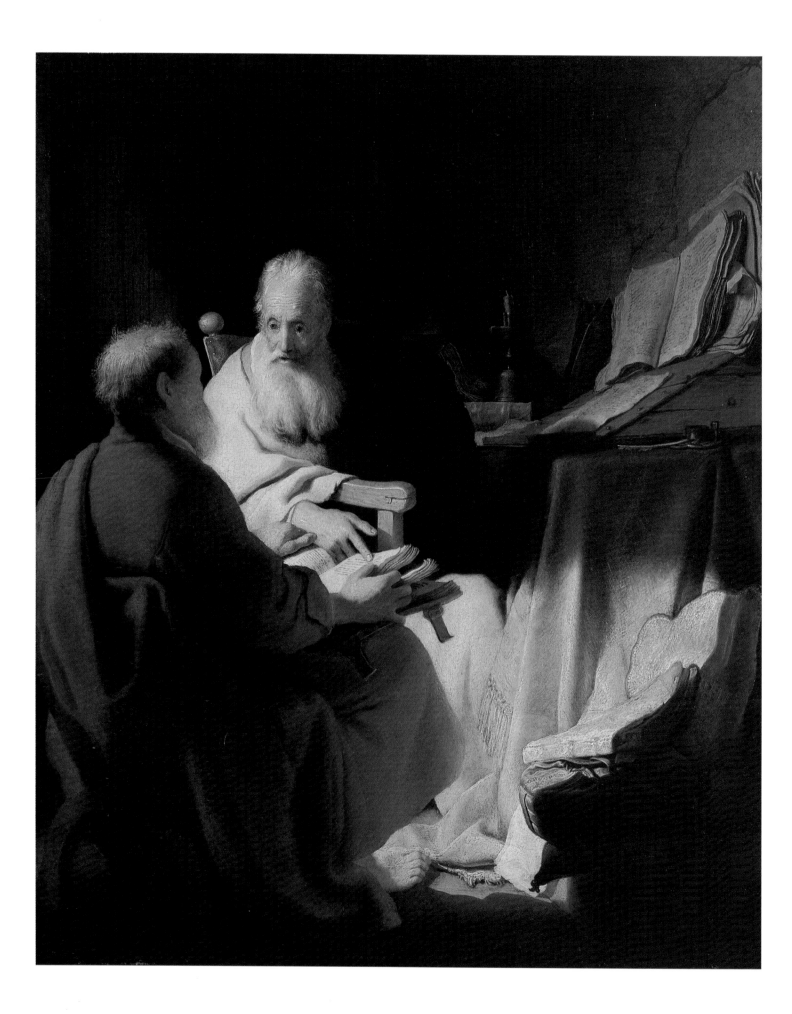

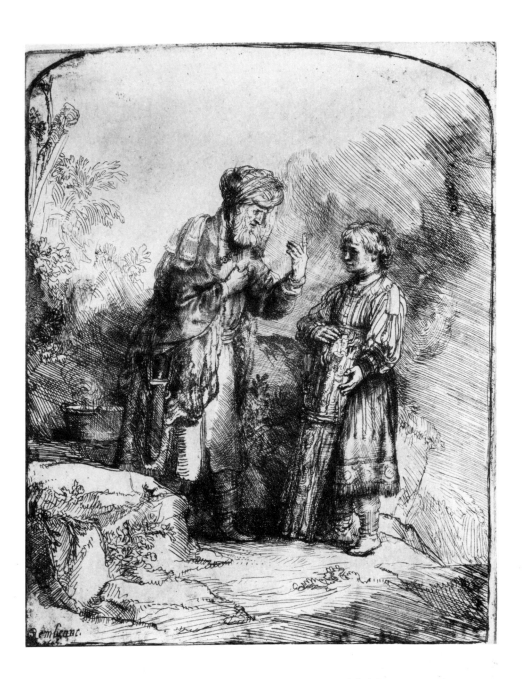

thing about the matters of concern which he pursues with his structural conception. It was not long before quieter scenes emerged alongside the dramatically intensified depictions of events, such as the first version of *The Presentation of Jesus in the Temple* (p. 21) and *Two Scholars Disputing (Peter and Paul?)* (p. 22). These scenes are also dramatic, in that they portray human acts. However, they are not always characterized as climax. It is true that the uplifted hands of the prophetess Hannah in the first example can be regarded as an expression of momentary surprise; however, it is the gesture of astonishment and blessing that lingers for a moment which predominates. All of the other figures can similarly maintain their depicted postures for a time, precisely because they are participating in the event. Similarly with the gestures of the two disputing scholars – in the second example – we are concerned again with lingering postures of temporary duration. In both cases, the importance of the event lies in communication, in speech, in the spoken word. The formation of such dialogue scenes epitomizes a further fundamental theme of Rembrandt's structural conception.

The spoken word – or, to be more exact, the gestures accompanying a conversation – offer Rembrandt the possibility of depicting dramatic action pictorially in such a manner that conflict with the static nature of the picture is significantly less than in the case of the turbulent scenes of action. The event of a

Esther Preparing to Intercede with Ahasuerus (?), c. 1633
Oil on canvas, 109.8 x 94 cm
Ottawa, National Gallery of Canada

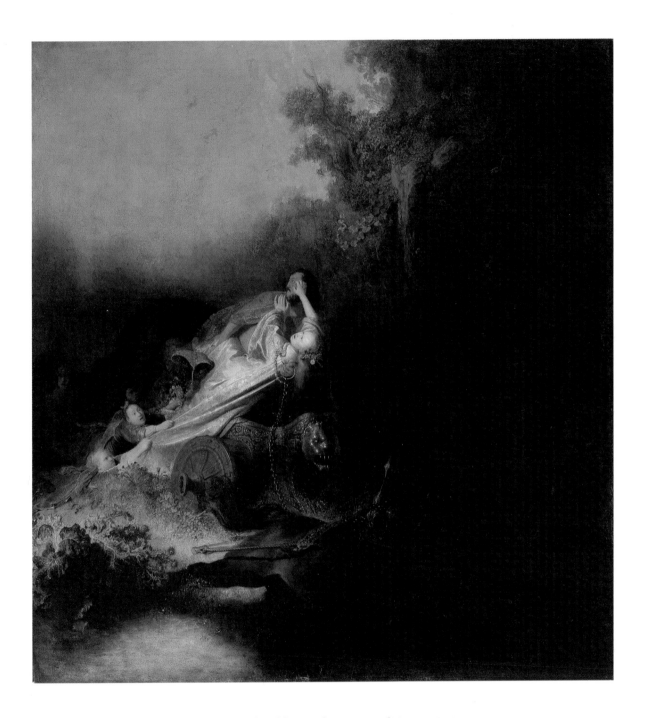

The Abduction of Proserpine, 1631
Oil on panel, 84.8 x 79.7 cm
Berlin, Gemäldegalerie, Staatliche Museen
Preußischer Kulturbesitz

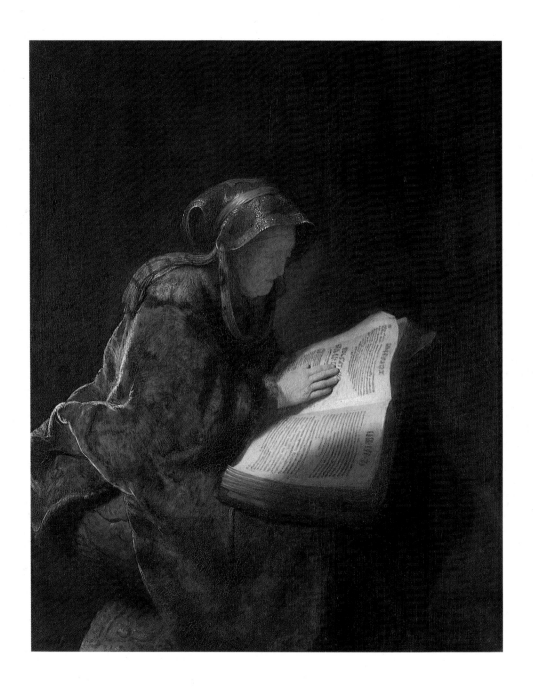

Rembrandt's Mother as the Biblical Prophetess Hannah, 1631
Oil on panel, 59.8 x 47.7 cm
Amsterdam, Rijksmuseum

*The Prophet Jeremiah Mourning over the Destruction
of Jerusalem* , 1630
Oil on panel, 58.3 x 46.6 cm
Amsterdam, Rijksmuseum

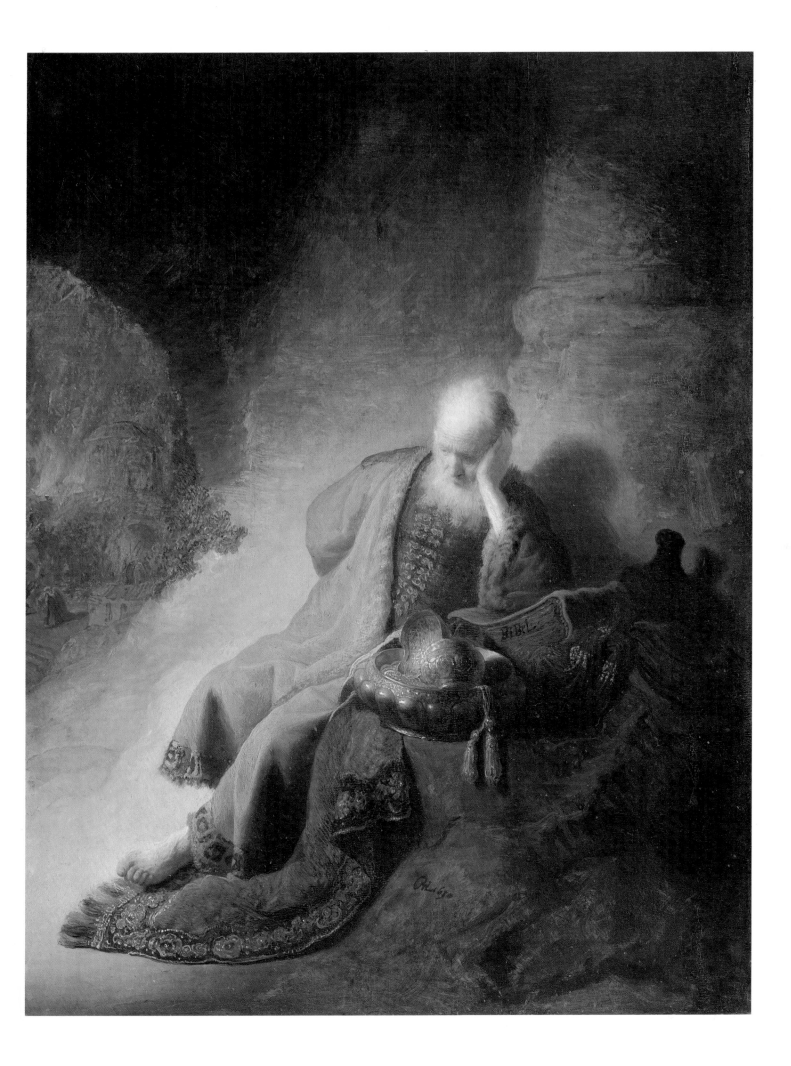

conversation does not amount merely to the acts of speaking and hearing. Rather, a conversation encompasses a multitude of actions. One example of this may be seen when the listener follows the speaker's train of thought, either agreeing or disagreeing with him; another involves the attempt to object to what the speaker is saying; and so forth. Nor does a conversation consist of a constant flow of speech, but – to an equal extent – of pauses where one thinks about what has been said, or waits for an answer. It is exactly at such moments that the course of a conversation can reach its highest density – in mutual, communicative silence. In the course of his creative work, Rembrandt was to develop the many different kinds of nuance with respect to mutual participation in a word, with ever new accents and a sharpness of expression such as constantly gives rise to admiration. It can be noticed at this point that the wealth of nuances opened up through the gestures of temporary duration would grow and grow. The stage would ultimately be reached in the late work at which the complexity of the expressive gestures was such that it is no longer possible to find words with which to describe the wealth that they offer.

A third leitmotif of Rembrandt's structural conception becomes apparent when one examines the great number of pictures either containing only one figure or at least totally determined by a single figure. An early example is the Stuttgart painting *The Apostle Paul in Prison* (p. 29) from 1627, in which Rembrandt depicts the apostle sitting on his bed, sunk in thought. Totally absorbed in his writing, he has placed one hand under his chin, while the other, holding his quill, rests on the leaves of an open book which Paul is holding on his knees. In the painting *The Prophet Jeremiah Mourning over the Destruction of Jerusalem* (p. 27), we see a bearded old man brooding at the foot of a mighty column, propping his elbow on a massive tome as he mourns. A shattered temple and the ruins of a town in flames can be made out in the distance, along with figures perhaps attempting to rescue something or flee. Both pictures have in common that the portrayed figure is not merely placed before the observer's eyes but is shown engaged in an activity, as with the figures in the scenes that have been examined up to now. The individual figure in these pictures is also bound up in the course of an event. In this way, the portrayal of the individual figure itself becomes a history painting, even though the action within which the event takes place is purely internal in nature.

In doing this, Rembrandt is adding a further important characteristic. In the depiction of Jeremiah, the inner action is not seen in the aforementioned minor figures: as with Paul's quill and the paper on which the apostle has written, these reveal merely the content of the activity. It is only from the posture of the figure that the observer grows aware of the action – that of brooding itself. It is at this point that the manner in which Rembrandt makes use of the possible effects of this posture upon the observer becomes crucial. It is not only a question of the observer's registering intellectually the inner activity of the figure in the picture through the posture with which he is confronted. Having grasped the content of this contemplation or this mourning, he then begins himself to ponder over what it is that the person portrayed is meditating upon – the apostle's letter, the destruction of Jerusalem. What is important here is not so much the respective content of each picture but rather that the observer should feel himself stimulated to such meditation, that he can make the transition to performing himself in front of the picture the inner activity which he recognizes in the figure in the picture. In this way, it is indeed possible for him to some extent to experience a process through his own contemplative activity, one which can take place in the picture as little as can visible movement. In contrast to visible movement, however, the activity recognized here in the pic-

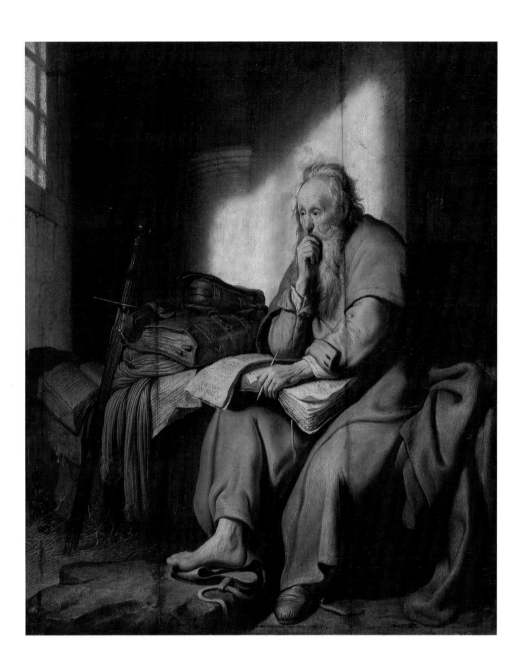

The Apostle Paul in Prison, 1627
Oil on oak panel, 72.8 x 60.2 cm
Stuttgart, Staatsgalerie Stuttgart

ture is of the same nature as the activity that recognizes it. The cited pictures represent no special cases. It is in precisely this sense that Rembrandt depicts his mother reading, dressed in the same costume as that in which the prophetess Hannah was portrayed previously (*Rembrandt's Mother as the Biblical Prophetess Hannah*, p. 26).

She, too has a book on her knees. Her flat hand is laid upon the paper, in order that her eyes may follow the tips of her fingers along the lines. The observer is also able to look at the open book and decipher Hebrew characters. In noticing this, however, he has already begun to some extent to engage in the same activity as that of the figure in the picture. The motifs of the inner activity involved in reading, contemplation, pondering, mourning or meditation may be identified solely through gestures that quietly continue. Rembrandt was to render the character of quiet duration revealed by these gestures equally fruitful for the pictorial representation of events.

It is of course true that other painters, both contemporaries of Rembrandt and those preceding him, also depicted these various gestural characteristics. However, Rembrandt succeeded from the very beginning in forming the gestures and facial expressions of his figures in such a way that they give the impression of being so wrapped up in what they are doing as to be lost to the

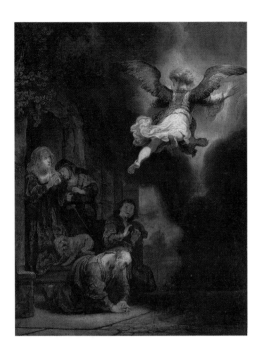

The Angel Leaving Tobias and His Family, 1637
Oil on panel, 66 x 52 cm
Paris, Musée du Louvre

world. This is especially true of the last-named type. It seldom occurs in the depiction of actions of quiet duration that the observer senses that the figure is aware of being watched. This characteristic of obliviousness to the world around one increases the impression of "naturalness" in the attitude of the figures: they create a direct effect to a high degree, despite the actual mediation of art. It goes without saying that the actions of quiet duration present the least contradiction to the static nature of their pictorial setting. Finally, there is a motif which is deserving of special mention here, since it will ultimately be seen at the end of the artist's development as being of even greater importance than the depiction of the word. We are concerned here with the motif of watching, of being an eyewitness, of becoming aware – in brief, the motif of observation itself in every conceivable internal and external aspect.

This in turn leads us back to the representations of multi-figure events. Figures are to be found in almost all of these scenes, themselves observing the central action – amazed, critical, approving, but not interfering in what is taking place. The motif of the observer in the picture is no invention of Rembrandt's; in all probability, he took over this traditional compositional component from Lastman. However, he develops it in his art into a most important factor in his structural conception. Discussion of the observer in the picture has often seen him as a figure who represents a mediation between the observer in front of the picture and the event depicted in the scene itself. The observer sees not only the event itself but also the manner in which others see it. And it is especially true that the observer experiences reality through the act of observation, a reality which he can experience as the one which the figures in the picture are executing. Rembrandt was later to discover previously unexhausted possibilities in this representational structure. In his final works, this was to determine not only the structural conception but ultimately even the appearance of the picture itself.

First of all, however, it should be noticed how Rembrandt combines fierce gesticulations, a dialogue's lingering gestures of temporary duration, and quietly continuing actions in the course of the following years to create scenes of ever-increasing complexity. A whole spectrum of individual and collective ac-

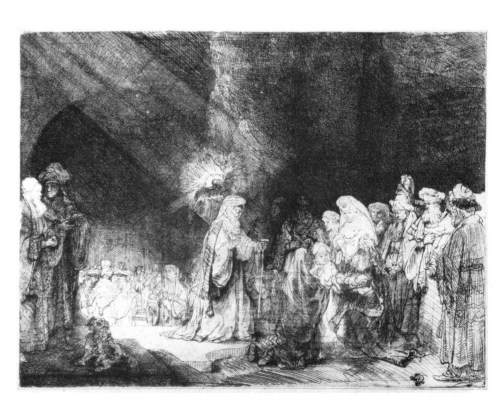

The Presentation in the Temple, c. 1640–41
Etching and drypoint, 1st state,
21,3 x 29 cm
London, The British Museum

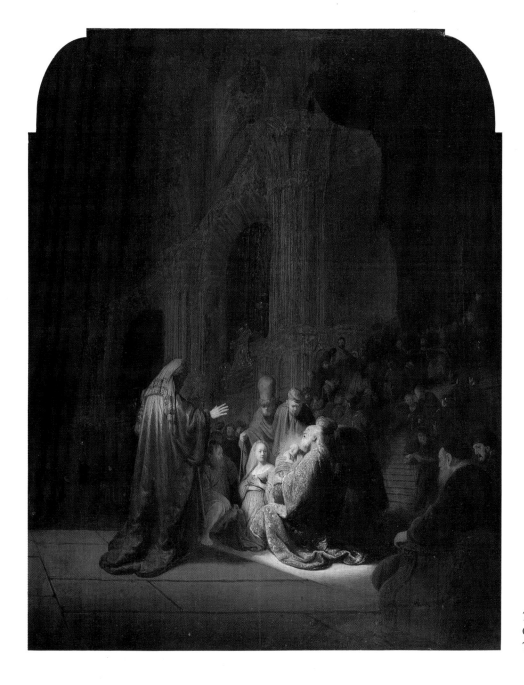

The Presentation of Jesus in the Temple, 1631
Oil on panel, 60.9 x 47.8 cm
The Hague, Mauritshuis

tions is to be seen in the 1631 *Presentation of Jesus in the Temple* (p. 31), all working together to mutually intensify their effect.

Luke's Gospel tells us of Simeon, the old man to whom it had been revealed that he would not die before he had seen the Lord with his own eyes. It was with this expectation that he had stayed on in the temple. When Mary and Joseph wished to dedicate their firstborn child to the temple, as the custom of the Law required, Simeon, recognizing the child, took it in his arms, pronouncing the words of his deliverance: "Sovereign Lord, as you have promised, you now dismiss your servant in peace. For my eyes have seen your salvation …" (Luke 2, 22–38). Rembrandt's sweeping view reveals the event at its climax, depicting the occurrence of the miracle. It is first and foremost the figures in the centre of the picture, the kneeling parents and the prophetess Hannah, her hand raised, who are involved in the happening. A contrast is presented by the many people portrayed in the background, distributed throughout the further expanse of the temple, coming and going in pairs or groups. Some of them take no notice of the incident, while the attention of others, such as the crowd around the High Priest on his throne at right, is drawn to the event from afar. As in *The Blinding of Samson*, four male figures are portrayed in a succession, in such a way as to

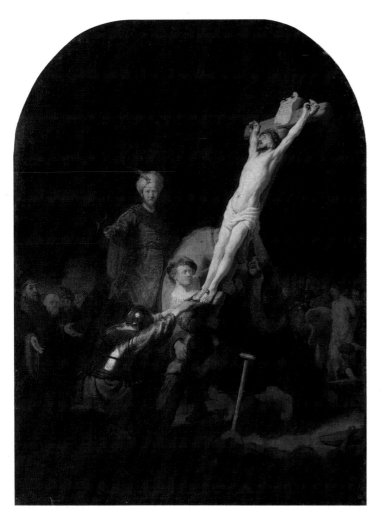 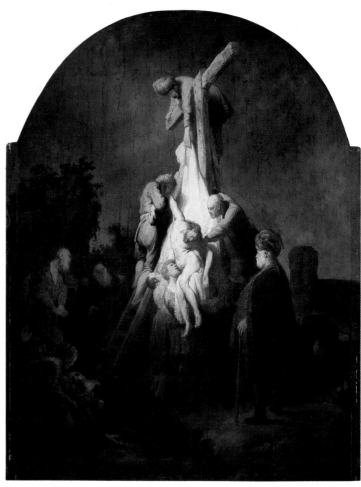

The Raising of the Cross, c. 1633
Oil on canvas, 95.7 x 72.2 cm
Munich, Bayerische Staatsgemälde-
sammlungen

The Descent from the Cross, c. 1633
Oil on wood, 89 x 65 cm
Munich, Bayerische Staatsgemälde-
sammlungen

depict the phases of approaching the child. The head right at the back under Hannah's hand, the approaching man wearing a high hat, the man standing next to the parents, and finally a man bending over the kneeling Simeon's shoulder from behind – they all serve to establish a transition between the customary temple bustle in the background and the central scene, thereby emphasizing the unique nature of the main event. It is clear that the moment in which Simeon speaks the words represents the climax of the incident. The culmination scene is encountered here as a kind of dialogue in the form of prayer. However, the effects of the external action are still predominant, while those of the gestures of quiet duration are as yet of little consequence. The event is presented in this structural conception predominantly as an external happening.

The combination of the various gestural characteristics at the climax of an event, in the representation of which the forms of the external action continue to predominate, can also be seen in the five scenes depicting the events of the Passion painted by Rembrandt on commission for Prince Frederik Hendrik and on which he was to work until the end of the 1630s (pp. 32/33). In contrast, the 1630/31 painting of *The Raising of Lazarus* (p. 35) offers one of the most striking examples of Rembrandt's allowing the drama to culminate not in actions in motion but predominantly in the lingering gestures of temporary duration of the spoken word.

Among those few scenes which, while not conceived with the culmination of the event in mind, nevertheless bring the various characters involved in the depicted event into interaction with each other, may be numbered the etching mentioned at the start, *The Good Samaritan* (p. 36). One may possibly be unable

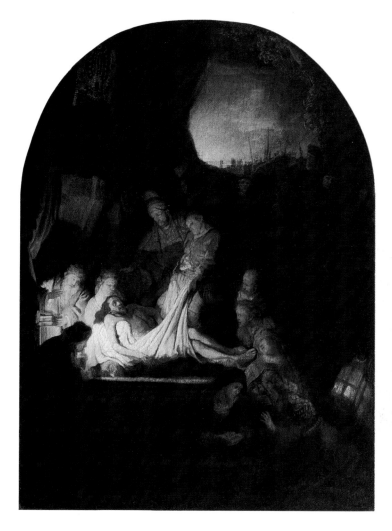 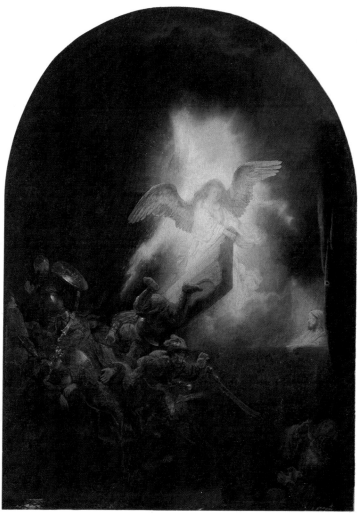

to completely follow Goethe's argument when he claims that the man rescued by the Samaritan, who is being helped from the latter's horse, recognizes in the figure with the feather in his cap – in the window to the left – the robber who has attacked him; nonetheless, it is clear that the whole is developing as a dialogue scene. The man with the feather in his cap belongs to those spectators so characteristic of Rembrandt's pictures. The woman drawing water from the well is not involved; rather, she is going about her normal, everyday business. In this respect, even the defecating dog in the foreground has a meaningful part to play. Here, too, banal and unusual events are combined to create an overall happening, one necessarily involving every pictorial element.

Rembrandt's structural conception is not only concerned with the fashioning of his figures' facial expressions and gestures; it also extends to the scene of the action, to the open landscape, and most of all to his interiors. It is important to notice, however, that the arrangement of the spatial elements appears restrained in favour of the figures participating in the action. In the case of *The Ass of Balaam Balking before the Angel* (p. 12), the cloud from which the angel is emerging covers almost the entire background. In *The Blinding of Samson* (p. 18), the space around the figures is rendered indeterminable through the tent hangings; *The Presentation of Jesus in the Temple* (p. 31) achieves a similar effect by means of a huge baldachin, together with an enormous temple hall which, while only recognizable thanks to certain details, is nevertheless of totally indeterminable proportions. Whether intentionally or not, the perspective in this latter painting, in which the principal characters are presented as if onstage, is not uniform; in addition, the figures comprising the central group are not

The Entombment of Christ, c. 1636–39
Oil on canvas, 92.6 x 68.9 cm
Munich, Bayerische Staatsgemälde-
sammlungen

The Resurrection of Christ, c. 1635–39
Oil on canvas on panel, 91.9 x 67 cm
Munich, Bayerische Staatsgemälde-
sammlungen

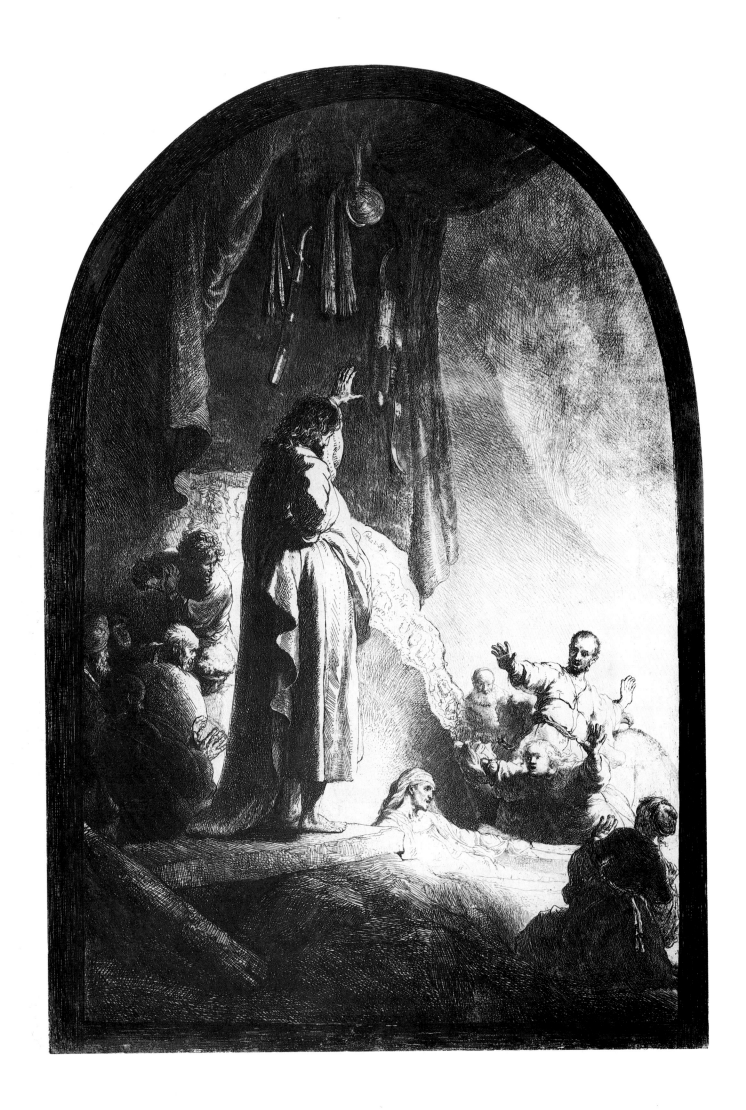

The Raising of Lazarus, c. 1632
Etching and burin, 4th state, 36.7 x 25.7 cm
Amsterdam, Rijksmuseum,
Rijksprentenkabinet

shown to the same scale as the others, but are considerably larger. It is only rarely that the location of the observer within the depicted spatial environment can be reconstructed. In *The Sacrifice of Isaac* (p. 16), the observer is given a particularly clear impression that the distance from him to the protagonists has been removed, as though the foreground had been taken away from a classical picture composition of foreground, middle distance and background. Scenes with developed foregrounds, such as *The Good Samaritan* (p. 36), are to be found far less frequently. The scenic expanse in the early works often serves merely as a backdrop to as effective a presentation as possible of the figures participating in the action.

The same may be said of the illumination of the depicted space. The important elements in the action are illuminated in a particularly effective manner. On the whole, it is only those figures functioning as participants in the action – and, even of them, only those parts of the body such as are of particular importance – that are illuminated. Everything else, and especially the surrounding expanse, is placed in shadow. If one disregards for the moment the admittedly influential artistic traditions taken up by Rembrandt – one need only mention the name of Caravaggio here – it can be seen that his concern is obviously to manipulate the illumination in such a way as to dramatize additionally the action of the figures and direct the observer to a greater extent to the "passions".

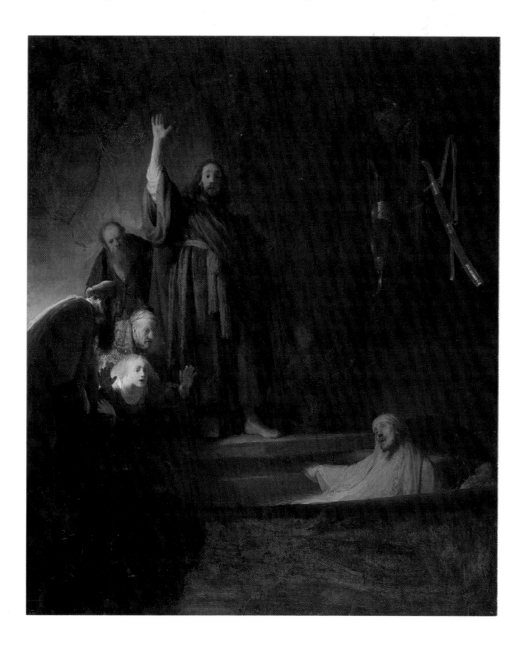

The Raising of Lazarus, c. 1630/31
Oil on panel, 96.2 x 81.5 cm
Los Angeles, County Museum of Art

The illumination of the early scenes has a demonstrative, exhibitory character. However, it usually passes unnoticed that the direction of the light in such pictures only rarely accords with those lighting situations such as would occur naturally in the given circumstances. Thus, the best explanation for the lighting in *The Presentation of Jesus in the Temple* (p. 31) would be one of sunlight falling on the kneeling figures through a window in the roof of the temple. However, the only possible justification for the gloom to be seen in the expanse of the temple around the figures is that the temple in fact has no other windows besides the one mentioned above. We will observe other examples of this later. It has already emerged here that the illumination does not enable the observer to comprehend an objective space with its own continued existence independent of the figures. The illumination is itself a contributory part of the action. The light acts in dramatic fashion here, providing sharp illumination or darkening effects, in accordance with criteria that are not empirical but in accordance with those governing the actions of the figures. To some extent, the light itself becomes a vehicle of the action. To avoid confusion, it should be stated that what we are concerned with here is not yet a visible bright-dark pattern on the picture's surface; rather, all that we are dealing with here is the representational depiction of light, a light which – following its nature – only shines when energy is conver-

The Good Samaritan, 1633
Etching, 1st state, 25.8 x 21.8 cm
Amsterdam, Rijksmuseum,
Rijksprentenkabinet

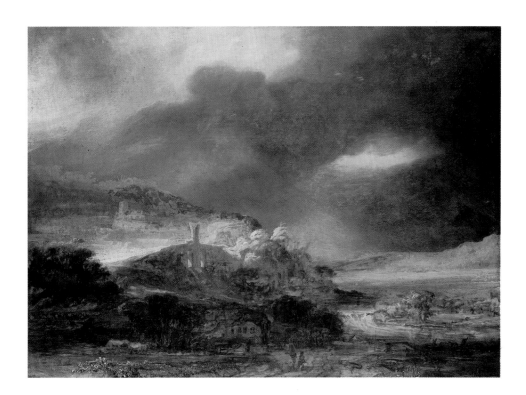

Stormy Landscape, c. 1640
Oil on panel, 51.3 x 71.5 cm
Brunswick, Herzog Anton Ulrich-Museum

ted and maintains its illumination, in the same way that the violinist must use his bow to maintain the vibration of a string, if it is to be heard. Light is an agent. Rembrandt, in depicting the illumination as a sudden spotlight, is showing it as if engaged in external motion. In other contexts, he portrays it as an illumination of long-lasting duration. Light in his landscapes turns the scene itself into a situation in transition. Rembrandt's landscapes do not document the appearance of hills, paths and trees. The atmospheric event, the change in illumination, transfer the topography into a sphere of experience given life by each observer in his own individual manner.

In conceiving the structure of his dramatic representations of illumination, Rembrandt discovered the transitory, progressive, temporal elements of light. This discovery would later enable him to structure the pictorial world itself as something transitory. The appearance of quiet duration, as encountered in his late works, would ultimately open up for him the mystery of the act of revelation itself.

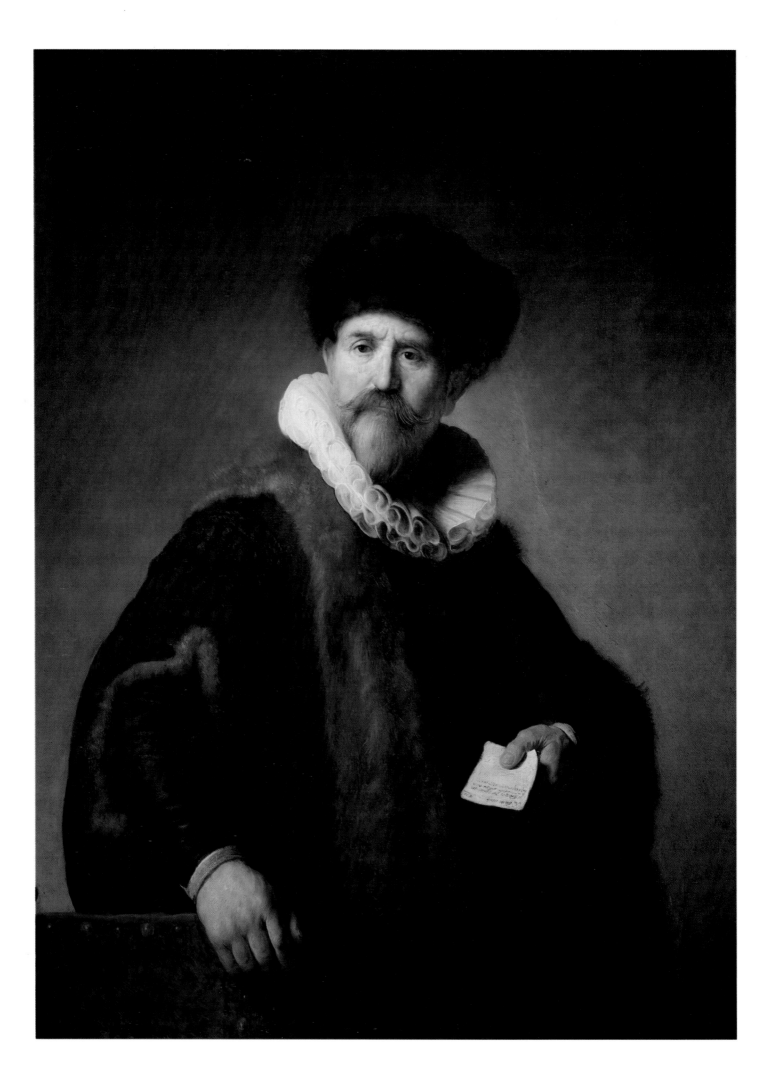

The encounter between observer and subject

Rembrandt's first portrait commissions came from Amsterdam. In comparison with his previous self-portraits and studies of heads, the first commissioned works from the year 1631 reveal a new approach. *The Amsterdam Merchant Nicolaes Ruts* (p. 38) is depicted in fine clothes, with shimmering dark material, soft fur on gown and cap, and a translucent ruff. Everything is finished off down to the last detail. The man holding a note in his hand is quite consciously presenting himself to the observer. Like the numerous portraits that were to follow, *A Man Sharpening a Quill* (p. 40) demonstrates a high degree of exquisiteness and perfection in its execution. However, the posture no longer corresponds simply to the pose for a portrait, as was the case with *Nicolaes Ruts*; although his eyes are turned towards the observer, the manner in which he is sharpening his quill suggests that he has merely briefly interrupted his writing and, sunk in thought, is momentarily looking to the front.

All the indications are that these portraits were extremely concise, accurate and true-to-life representations. Indeed, it was this depictional perfection that was to bring the young artist an increasing number of commissions of an ever more prominent nature. The extent to which Rembrandt's art of portraiture was held in awe may be seen in a couplet by Constantijn Huygens on the portrait of Jacob de Gheyn: "This is Rembrandt's hand and de Gheyn's face. Be amazed, o reader – it is de Gheyn, and yet it is not."[1] Capturing the presence of the person portrayed by means of the appearance of the portrait – this was the ideal which the acknowledged young artist fulfilled in the up-and-coming metropolis. The painter had attained a degree of perfection that could hardly be improved upon. Here, too, the limits of art – such as had hitherto been valid – would seem to have been reached.

Rembrandt, however, was not content with merely fulfilling the expectations of his clients. After only a few works, he was to abandon the customarily accepted forms of presentation and turn to structuring his portraits as he had previously his scenes. He presents *Jan Cornelisz. Sylvius* (p. 39), the pastor, preaching out of the frame of the picture as if from his pulpit. The Bible, in which Sylvius has placed his finger to mark the place of a quotation, and his declaiming hand project beyond the surrounding oval, as do the shadows that they cast. The baroque motif of illusion suggests the lifting of the barrier between the pictorial world and that inhabited by the observer, a barrier which would otherwise be defined by the frame. The vivid effect created by the double portraits of this time stems from their depicting the people portrayed in situations characteristic of their work (pp. 44, 45).

It was only a short time after starting work in Amsterdam that Rembrandt was awarded the prestigious commission from Nicolaes Tulp, Prelector of the

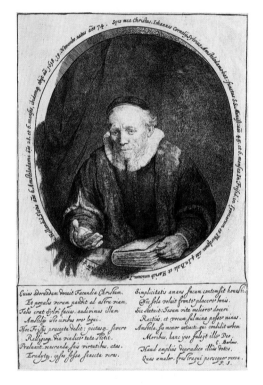

*Jan Cornelisz. Sylvius, Preacher
(Posthumous Portrait),* 1646
Etching and drypoint, 2nd state,
27.8 x 18.8 cm
Amsterdam, Rijksmuseum,
Rijksprentenkabinet

The Amsterdam Merchant Nicolaes Ruts, 1631
Oil on panel, 116 x 87 cm
New York, The Frick Collection

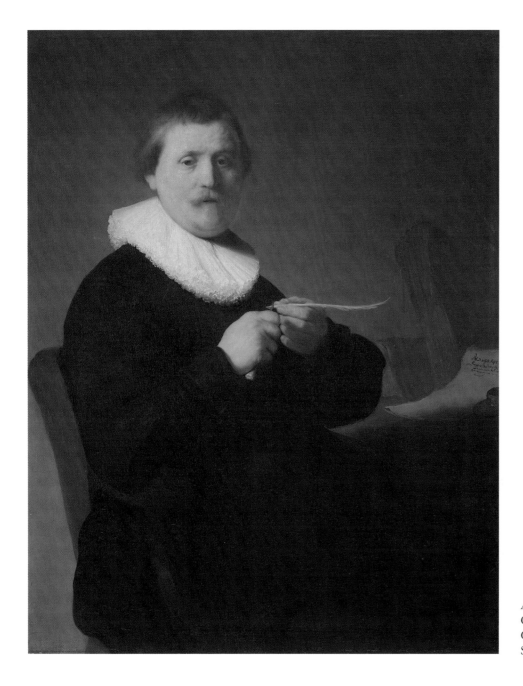

A Man Sharpening a Quill, c. 1632
Oil on canvas, 101.5 x 81.5 cm
Cassel, Gemäldegalerie Alte Meister,
Staatliche Kunstsammlungen Kassel

Guild of Surgeons, to execute a group portrait (pp. 42/43). Public anatomical
lectures had become customary, and were intended – as is no longer the case to-
day – to demonstrate the wisdom of the Creator in His construction of the hu-
man body. The most important thing when performing a dissection was that
what was revealed should not challenge but rather uphold this wisdom, as it
had been preserved in the books of the great philosophers. It was not until the
beginning of the 17th century that interest in anatomy was fully aroused. Every
insight into the structure of the body was a sensation, and the lectures found a
wide public. Vesalius, the famous surgeon, had been the first to dissect the
muscles and tendons of the hand, and Nicolaes Tulp, the "Amsterdam Vesa-
lius", was held in great esteem.

Rembrandt breaks with traditional form in his very first group portrait,
depicting the persons involved not in a row next to each other but collected
around the body, the tendons of the right forearm of which are exposed. As an
aid to the lecture that he is delivering, the surgeon is lifting some tendons with
his forceps. In imposing contrast to the other figures, Tulp is seated on an arm-
chair and is also the only one wearing a large hat. His audience of seven respec-

ted Guild members is listening to the lecture, and the different character of each person's behaviour is vividly portrayed. Rembrandt lets their expressions speak. He shows the looks of concentration directed at the speaker, the sceptically expert inspection of the dissection, the manner in which it is followed in and compared with the book lying open in the right foreground – but also the distracted look so typical of people who are listening intently, the unfocussed gaze of a person concentrating upon what he is hearing. In taking part in the doctor's address, each of the figures is participating in a collective action.

There is a further dimension which also comes into play here. The typical behaviour at a lecture includes the exchange of glances with another listener with whom one is familiar, an exchange expressing or requesting agreement with what has been said. It is in this way that the look of the doctor whose head towers above those of all the others, directed forwards out of the scene in the picture, may be understood – as an exchange of glances with the observer, who thereby sees himself challenged to participate in the actions of those involved in the depicted incident, to join them in listening and looking. Indeed, he sees possible ways of behaviour spread out in the picture in front of him, in the spectrum of different gestures and facial expressions; in observing the lecturer, in looking at the body, the book or the other figures, he is for his part performing the same actions as the protagonists in the picture. In this way, he can put himself in the position of the audience of experts.

If we assume that Rembrandt's painting represented a particularly good likeness of those being portrayed, and if we also assume that the work hung in the Guild's convening chamber, then the scene must have created an almost amazingly true-to-life impression upon contemporary viewers. It is noteworthy what deep respect came Rembrandt's way as a result of the representational realism of precisely this scene. For the body – that of an executed criminal known to us by name – is also realistically depicted, and the representation of the dissected arm corresponds to the state of knowledge at the time. Rembrandt's estate even included plaster casts of arms which had been dissected by Vesalius.

The development of the individuals notwithstanding, it should be noted that the behaviour of the persons is for the most part typical of such a situation, and that the individual features are also more emphatically delineated than is really necessary for the situation. As a result, it is true to say that the individual qualities of expression become all the clearer. However, this heightening betrays to today's eyes a tendency towards pose, one which Rembrandt was only to overcome later – albeit then completely. Despite this, the representational fascination of this picture was so great at the time – and continues to be so today – that it was hardly noticed how unrealistic the whole scene is in comparison with a situation in reality.

The figures have been placed so closely together that it is impossible to ascertain who is standing, who sitting, and where. Moreover, their proximity to each other is such as to grant them no room in which to move. Nor does the element of perspective aid us in fixing their position in the depicted surroundings. While it is true that the depicted room does not create a narrow impression, it is still taken up almost entirely by the bodies of the figures. Most of these figures are depicted as if seen from a point somewhat below them – yet from where could such a perspective be obtained? The arrangement also leaves unclear where the observer – who is otherwise included to such a great extent in the action – should see himself in relation to the scene in the picture. The dense nature of the action is of course emphasized by the manner in which the figures have been moved so close together; nonetheless, the realism of the action is

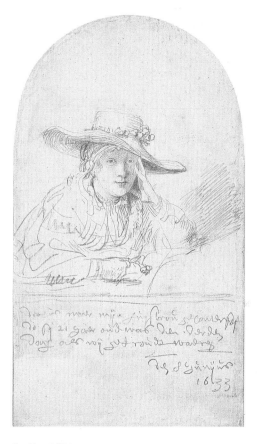

Saskia, 1633
Silverpoint on white prepared vellum,
18.5 x 10.7 cm
Berlin, Kupferstichkabinett,
Staatliche Museen Preußischer Kulturbesitz

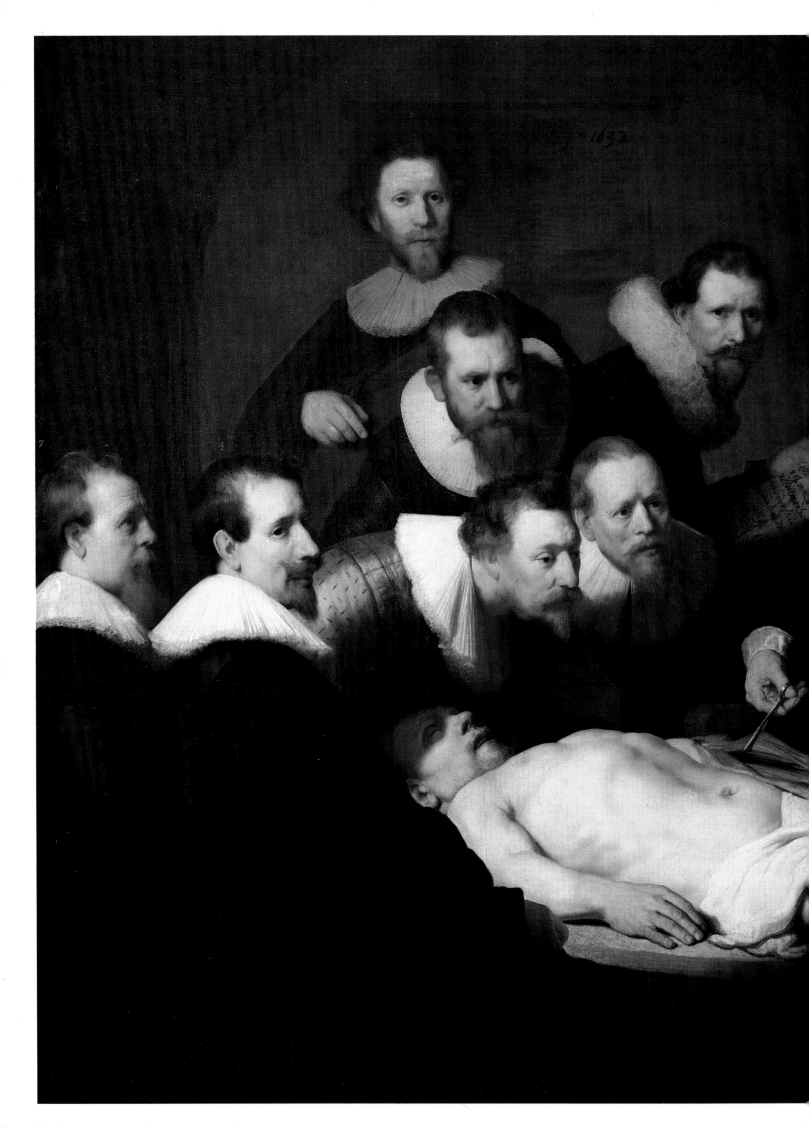

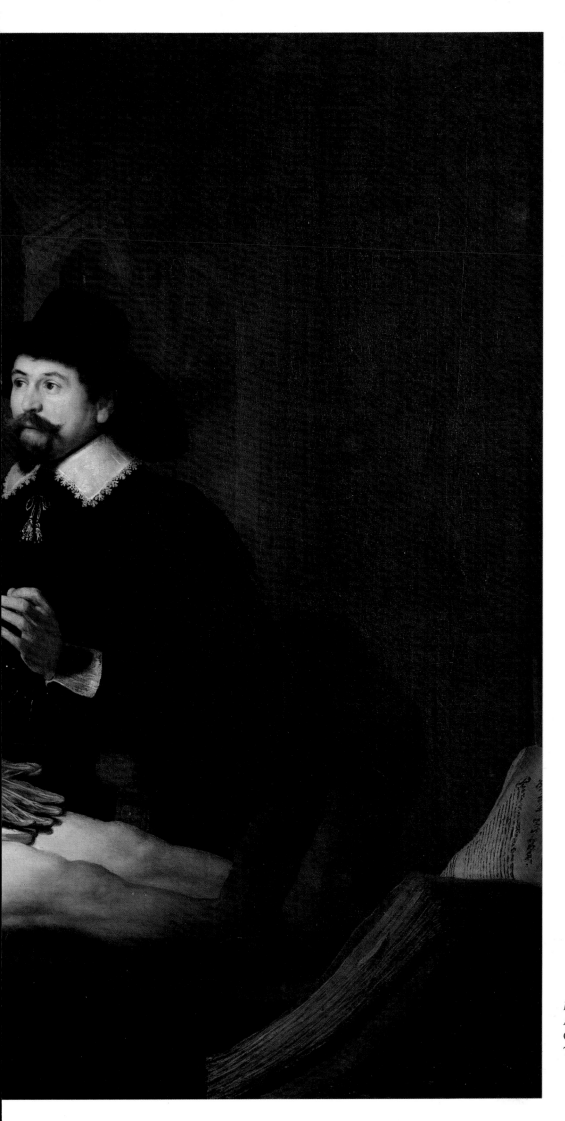

Doctor Nicolaes Tulp Demonstrating the Anatomy of the Arm, 1632
Oil on canvas, 169.5 x 216.5 cm
The Hague, Mauritshuis

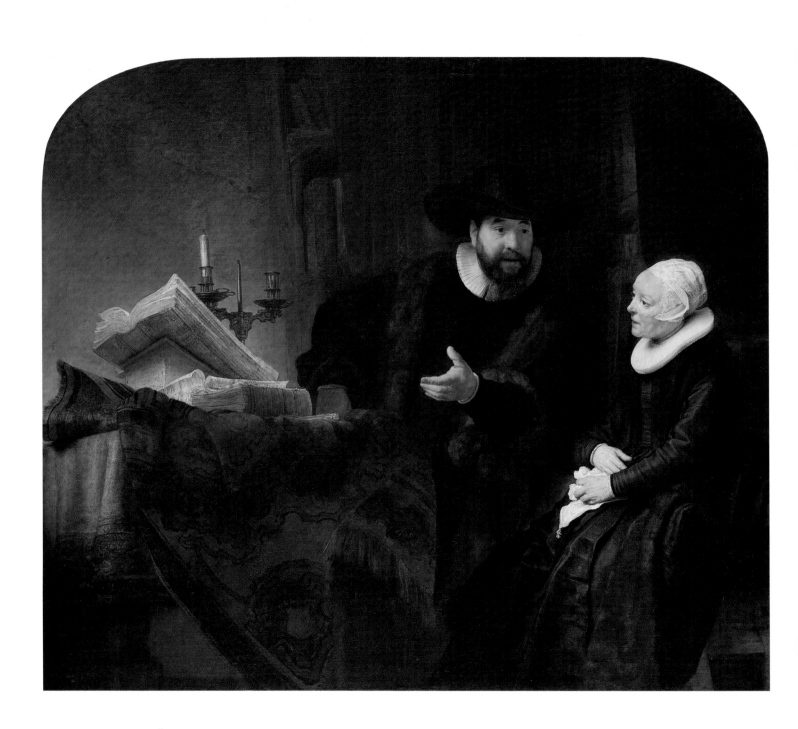

Jan Rijcksen and Griet Jans, 1633
Oil on canvas, 111 x 166 cm
London, The Royal Collection, Copyright
reserved to Her Majesty Queen Elizabeth II

*The Mennonite Minister Cornelis Claesz. Anslo in
Conversation with his Wife, Aaltje,* 1641
Oil on canvas, 176 x 210 cm
Berlin, Gemäldegalerie,
Staatliche Museen Preußischer Kulturbesitz

achieved at the expense of the remaining depicted reality. The plausibility of
the action's coherence conceals the implausibility of the spatial situation. It is
the action which unites the figures, and not the setting – for the setting is ulti-
mately not the lecture theatre portrayed in the picture, but the picture alone. In
spite of everything, however, it is the uniting of the eight half-length portraits
to form a group, representing a fitting manner of depiction in the view of the
Guild members, that asserts itself as the principal reason for the portrayal. This
attitude also explains why Rembrandt's circle of clients became ever smaller as
his portraits gradually ceased to be a representative end in itself, finally focus-
sing entirely upon their action – in the encounter between observer and subject.

There are other ways in which Rembrandt connects a portrait with the
course of events in a happening. Occasionally, he will assign the subject of the
portrait a role within a "history painting". The young artist, meanwhile already
a member of the Amsterdam Guild of St.Luke, aiming at the highpoint of his
career and, two years later, defending himself with a slander action against the
accusation that his wife was senselessly squandering her dowry, presents himself
dressed in velvet, brocade and silk, with rapier, feathered hat and raised glass,
and with Saskia on his lap, as *The Prodigal Son in the Tavern* (p. 47). He had al-
ready depicted his mother in one of his early works in the role of the prophetess
Hannah; towards the end of his life, he was to paint his son Titus and his
daughter-in-law as Isaac and Rebecca. Conversely, Rembrandt was to bring
characters from history into his late works – Aristotle, blind Homer, old Si-
meon – depicting them in such an individualized way that the pictures ac-
quired the quality of an encounter between observer and subject such as is
found in a portrait. In his late works, a differentiation between the depiction
of an event and a portrait is no longer possible.

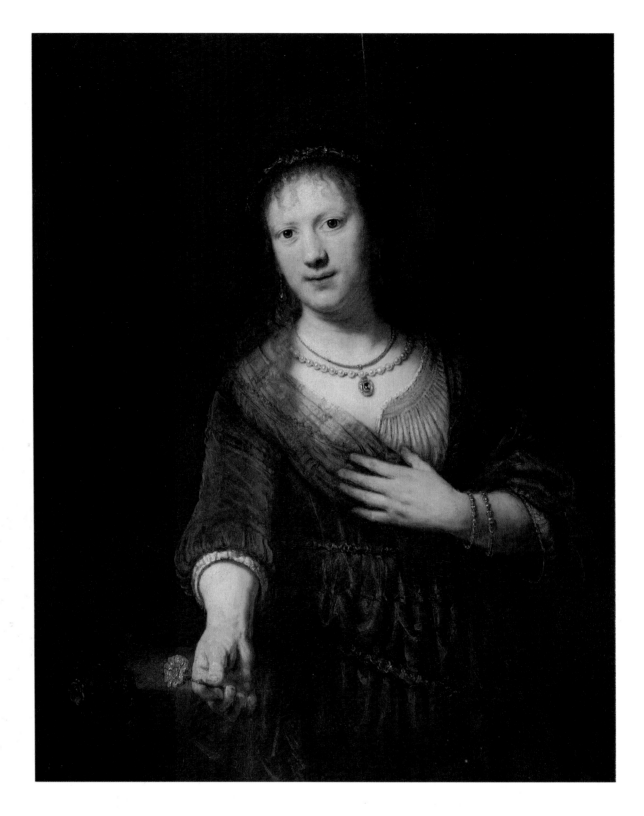

Saskia as Flora, 1641
Oil on oak panel, 97.7 x 82.2 cm
Dresden, Gemäldegalerie Alte Meister,
Staatliche Kunstsammlungen Dresden

*Rembrandt and Saskia in the Scene of the Prodigal Son
in the Tavern,* c. 1635
Oil on canvas, 161 x 131 cm
Dresden, Gemäldegalerie Alte Meister,
Staatliche Kunstsammlungen Dresden

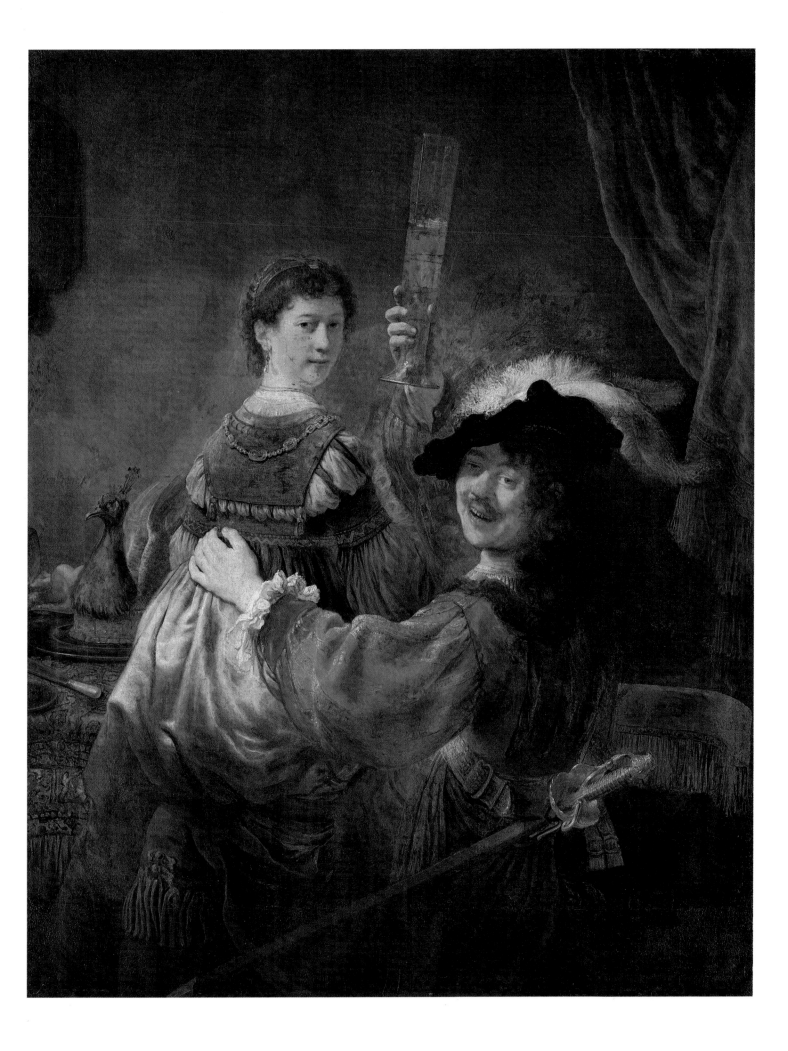

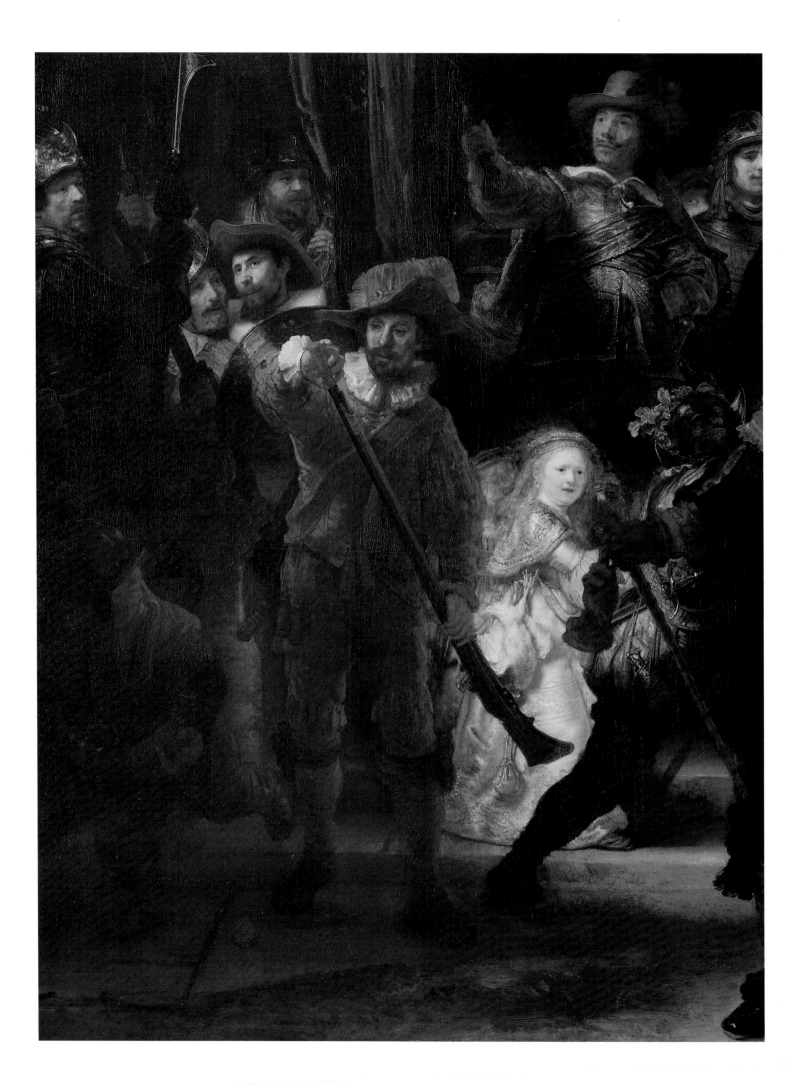

From interpretation to observation:
The Night Watch

The Night Watch (pp. 50/51) symbolized for Rembrandt a bringing together of everything that had come before, but simultaneously a new beginning. He unfolded in this, probably his most famous work, an astonishing, fascinating virtuosity, the effect of which is as great today as then. The execution of the details alone – the splendidly gleaming metal, the shimmering cloth, the various pieces of equipment – and, even more so, the fashioning of the eloquent facial expressions, succinct gestures and dazzling lighting effects are artistic in the highest degree. The possibilities inherent in a depictive representation would seem to have been exhausted. A likeness of *The Night Watch* may be found in the album of Captain Frans Banning Cocq, the "Seigneur of Purmerlandt and Ilpendam", accompanied by the following text: "Sketch of the picture in the Great Room of the Cloveniersdoelen (Civic Guard House), wherein the young Seigneur of Purmerlandt as Captain gives orders to the Lieutenant, the Seigneur of Vlaerdingen, to have his company march out" (p. 49). The picture bore no other title. The name *The Night Watch* did not arise until the beginning of the 19th century. The likeness shows the painting in the state in which it hung in the hall of the Civic Guard building along with six further large works depicting the Guard by other artists. The painting was trimmed at the beginning of the 18th century in order that it could be hung in a smaller town-hall chamber. The sensation caused by this immense picture of almost four by five metres can be imagined. However, some of those portrayed appear to have considered themselves to have been represented less favourably than they had expected: Rembrandt later added an oval plaque bearing a list of names, which he placed in rather unmotivated fashion in the right-hand corner of the archway. The reproduction in the album shows the picture in its original state prior to this addition.

It can be seen at first glance that Rembrandt gives the presentation of the general event priority over a faithful working-out of the individual portraits. The foreground is dominated by the marching figures of the Captain and the Lieutenant. The Captain's extended hand and slightly opened mouth indicate that he is speaking; in doing so, he does not look at the Lieutenant, who is receiving the order. Figures to right and left of the archway are also engaged in conversation, while under it the standard-bearer is raising his standard. Men with helmets and hats are carrying swords and spears; some of them also bear round shields and are wearing gorgets. A number of the men are in the act of taking hold of the spears propped against the building wall to the right, while others continue to press forward through the archway. A boy wearing a helmet that is far too big for him is depicted in the left-hand foreground; he is running away with an empty powder horn, half-turning back in mid-stride. A musket-

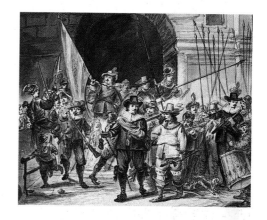

Copy of *The Night Watch*
A page from the family album of Frans Banning Cocq, c. 1650
Water colour, 14.2 x 18.0 cm
Amsterdam, Rijksmuseum

Detail from *The Night Watch*

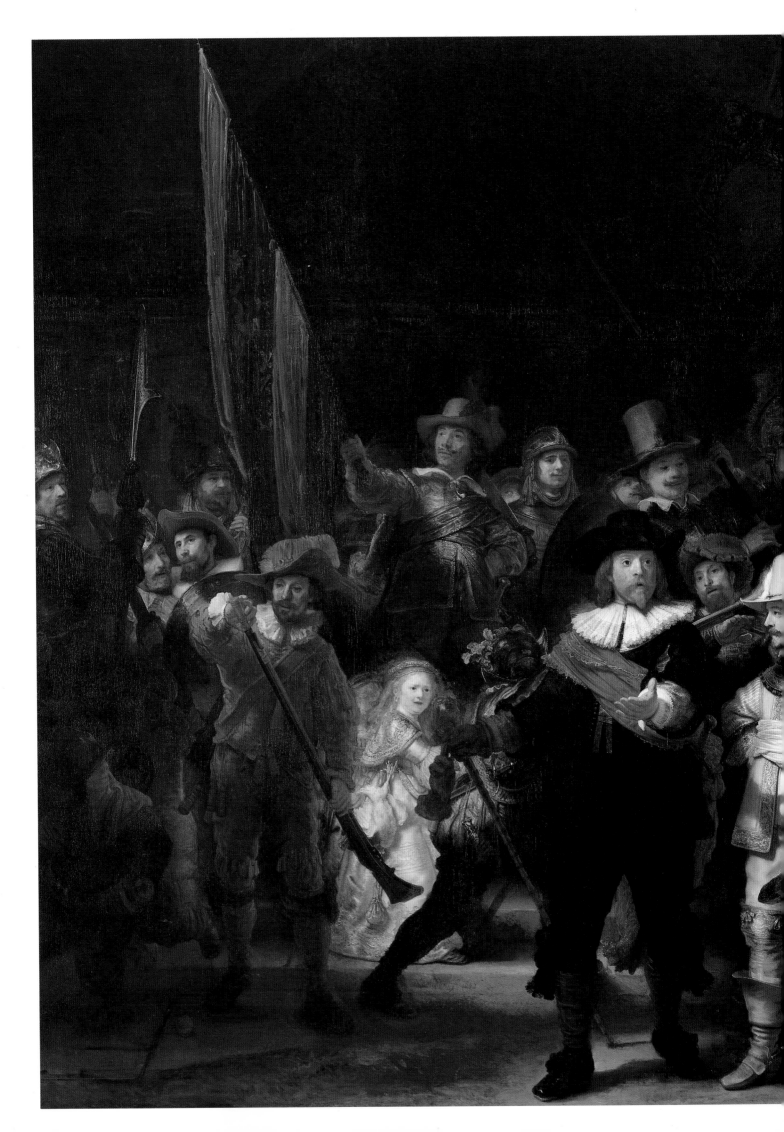

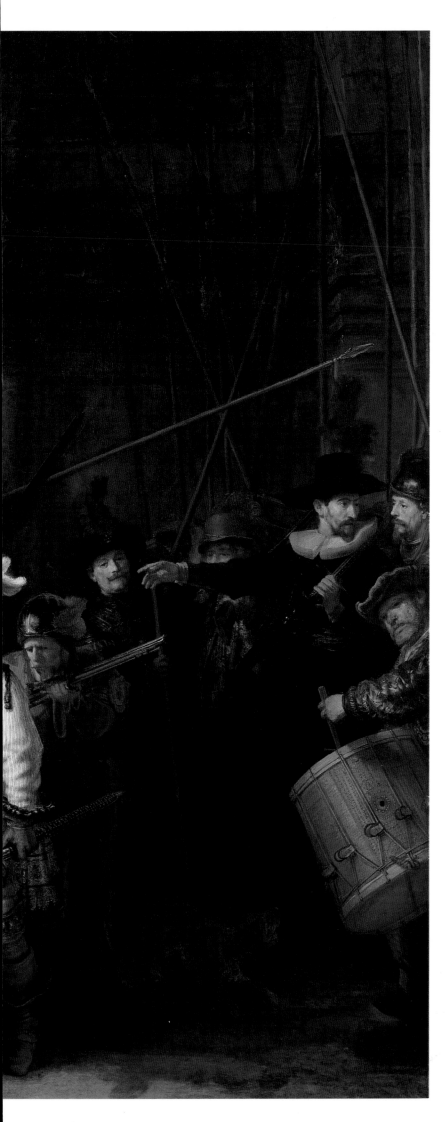

The Militia Company of Captain Frans Banning Cocq (the so-called *Night Watch*), 1642
Oil on canvas, 363 x 437 cm
Amsterdam, Rijksmuseum

eer clad in red stands next to him, loading his gun. To his right, half-hidden by the Captain, a form in baggy breeches with an oak leaf-garlanded helmet can be seen side-on, striding out with big steps towards the right and lifting his gun, the muzzle of which is visible between the Captain and the Lieutenant. A man standing behind them is attempting with outstretched hand to ascertain the angle of fire of his gun's barrel. The muzzle-flash can be observed directly adjacent to the white feather in the Lieutenant's hat: the gun is depicted in the very moment in which the shot is fired. To the right of the Lieutenant, an old man is blowing the burnt powder from his flintlock's pan. On the far right, the drummer is trying out his instrument, and seems to have scared the dog, which is cowering in front of him. Two female figures should also be mentioned. The first, in a golden dress, has a purse and a dead hen hanging from her belt, the latter claws-upwards; she is holding a drinking horn in her hand. The second figure is almost entirely concealed behind her.

A great variety of motifs of movement is arranged before the observer. Rapid change – seen in the running boy and the striding gait of the Captain and Lieutenant – characterizes the "here-and-now" of this instant, an element emphasized still further by the shot that is being fired. One may notice the lingering gestures of the speakers, together with the postures of quiet duration visible in the posture struck by the ensign and the listening and watching attitudes of those waiting.

Brilliantly set highlights and certain prominent shadows serve to heighten the impression of something lasting but for a moment. Particular attention should be paid here to the shadow thrown by the Captain's outstretched hand on the coat of the Lieutenant. It is not least through this element, together with the suggestion of commotion, that the expectation is aroused that the scene could also be encountered outside of a picture, in reality, just as it is seen here.

A wide range of activities are portrayed, such as those concerning the handling of a rifle – loading, firing, cleaning out the pan – the presentation of the standard, the taking up of arms, the testing of the drum. All these are activities such as mark out the group as a Civic Guard company. At the same time, however, each individual is characterized through the activities typical of him or his task, with the consequence that each would appear to be doing whatever he wants, without reference to the general happening. Here, too, it is only the word that binds together all these diverging actions. If the text from Banning Cocq's album is taken as being accurate, then the work depicts the moment in which the Captain gives the order to march out; the Lieutenant has not yet passed it on, nor is anyone else aware of it. As of this moment, it is the duty of the Lieutenant to pass on the order. It is in this turn of events, however, that the whole hardly surpassable effect of the picture's structural conception lies. A situation has been selected in which each individual becomes a member of a collective event, in the very moment in which he performs his activity for himself alone, with no direct reference to what is going on around him. It is only by this means that the moment preceding the passing on of the order can be clearly indicated. Rembrandt makes use of the opportunity to give a precise and subtle display of the typical hustle and bustle of the Guild's everyday life – and also, at the same time, to depict the group in a collective, unifying active whole. Christian Tümpel characterizes the depicted moment as the "state of setting off and getting into order".[2] However, the latter would signify that the Lieutenant – or some other person or persons – were already preparing to follow the order to the troops to form up prior to marching out. One can make a better case for the argument that the moment portrayed is that one just before the men form up, one still allowing unrestricted freedom of individual action.

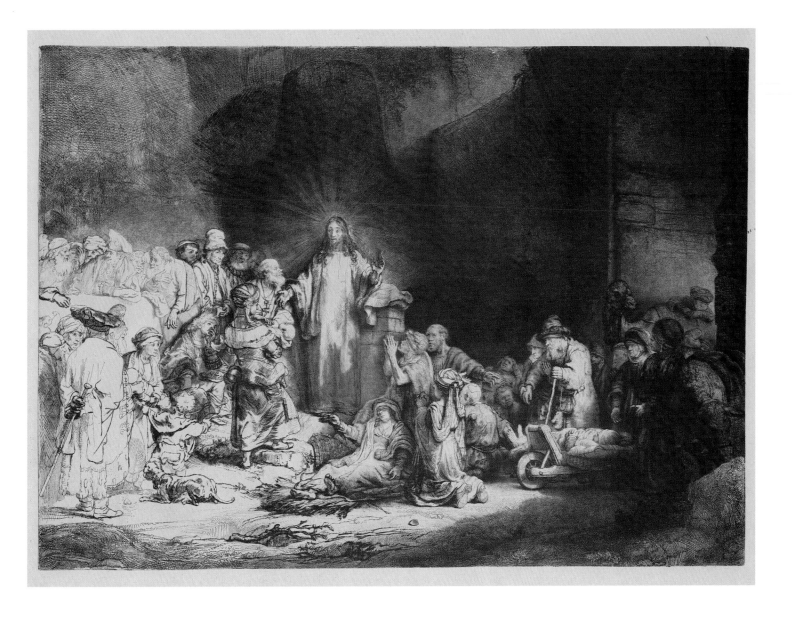

Here, once again, in one of the last scenes of this kind, Rembrandt is able to use the situation to display the highest and most differentiated external movements, since the individual forms have not yet been integrated into the formative schema of the collective marching order.

The open situation throws up further questions. Will the Captain and the Lieutenant, depicted in front of the others and already striding out, become detached from the group? How will the march out look after the men are in formation, from where are the figures emerging from the archway coming, where will they line up, and what is the group's destination? Does what is happening reflect the normal course of events whenever the troop comes together, or is something special, something unique, taking place? None of this can be inferred solely from what is depicted in the picture. Are we concerned here with the departure of the Guild to escort Maria de Medici, the Queen Mother and former Regent of France, on her visit to Amsterdam? In the year 1638, she was indeed conducted into the city by the three Guilds. An argument in favour of this is that some of the costumes date from this time; against it, however, is the fact that Frans Banning Cocq and the Lieutenant were not yet in office at that time.

Furthermore, we must ask – as with *The Anatomy Lesson by Nicolaes Tulp* (pp. 42/43) – how all these figures are to find a radius of action for their movements on the narrow steps. It is reasonable to assume that the building repre-

The Little Children Being Brought to Jesus ("The 100 Guilder Print"), completed 1647–49
Etching and drypoint, 1st state,
27.8 x 38.8 cm
Amsterdam, Rijksmuseum,
Rijksprentenkabinet

53

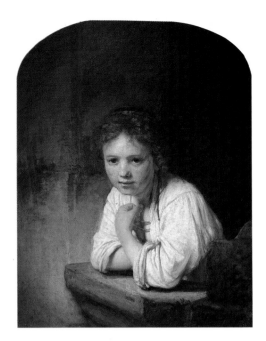

A Young Girl Leaning on a Window-sill, 1645
Oil on canvas, 81.6 x 66 cm
London, by kind permission of the Governors
of Dulwich College Picture Gallery

sented here is the Guild's house, the so-called Cloveniersdoelen, the hall of
which the painting was intended to decorate. However, the pattern of the illu-
mination remains inexplicable: how are we to account for the lighting effects in
the case of the Lieutenant and the female figure in the background? If we were
looking at a night watch in front of the house, then it could hardly be a ques-
tion here of moonlight: the only possibility would be artificial light, for exam-
ple that thrown by torches – and yet these would surely cause each and every
object to cast more than one shadow. The intensity of light revealed in the pic-
ture can only have the rays of the sun as its source – so how is it, out in the
open in front of the house, that everything is shrouded in darkness? If the group
were indeed illuminated by the sun, then the members would surely appear
universally bright and uniformly in shadow. Yet it is only the figure of the
Lieutenant, the female form in the background, and individual faces here and
there which the light causes to stand out, while even the shadows follow no
clear direction. The distinct shadow thrown by the Captain's hand is the only
thing to create such a convincing effect that it becomes a *pars pro toto,* a detail
inducing one to believe that the conception of the illumination elsewhere in the
picture is consistent. Such observations can serve to draw attention to the fact
that here, too, the plausibility of the action is achieved only at the expense of
the plausibility of an actual situation. It covers up the fact that the figures are
bright because they are depicted, and not because the light happens to be fall-
ing on them: that which appears to be chance in the picture is in fact artistic
intention.

Questions also remain unanswered when one attempts to fathom the sig-
nificance of individual motifs. One example among many: the bright female
form, and the one almost entirely hidden behind her, have given rise to the
greatest mystery of all. In comparison with the other figures, they appear as
small as children; however, their proportions and dress lead one to suspect that
they might be sutlers accompanying the company. The drinking horn, the purse
and the hen hanging from the belt of one of the women have been interpreted
as a reference to the central social event of the Guild, the communal banquet.
The fact that the size of these figures is portrayed as being so much smaller here
could be explained by the mediaeval custom of depicting minor characters on a
smaller scale than that employed for the principal protagonists.[3] If this is the
case, however, why does the artist then manipulate the lighting in such a way as
to cause them to stand out to such an extent? On the other hand, if one were in-
deed to consider them as girls, then it would be possible to connect them with
children in pictures before Rembrandt's time, where they were portrayed as em-
blem carriers in processions. Following this theory, the colours of the girls'
dresses in *The Night Watch* have been linked to those of the Guild's coat of arms.
Moreover, the claws of the hen hanging from the belt of one of the girls could
be interpreted as a play on the coat of arms of the Civic Guard, consisting of
crossed rifles and griffins' talons: the Dutch word for talon is the same as that
for rifle. The question of whether the two girls have any allegorical significance
within the context of the pictorial scene must remain open.

The baroque era was a time of allegory and emblems. In *The Night Watch,*
however, Rembrandt would appear to have been successful in both depicting
these and simultaneously hiding them, with the result that the observer be-
comes aware of the allusions, yet is unable to tie them down. In this way, they
maintain the state of affairs shortly before the ordering of meaningful concepts.

The fact that the event, the situation in its details, the setting, costumes,
illumination, and even meaning of individual motifs in *The Night Watch* elude a
final definitive interpretation will not be taken in the following as a mistake or

as the capriciousness of so-called artistic freedom; rather, it should be considered – at least on an experimental basis – as a decisive principle, one by which Rembrandt allowed himself to be led in shaping that which was to be depicted. It should be apparent that the reason for such a style of depiction can hardly lie in the effort to reproduce things as faithfully as possible, nor in the subject-matter of the depiction. If one acknowledges the openness of the depictive interpretations, then one is ultimately led to their concrete, visible cause – the elements of the picture itself, the lines, the light-dark structure, the colours.

If one starts by studying the structure and arrangement of the lines on the surface of the picture – leaving aside any representational interpretation – then one may be struck by the numerous straight lines formed by the contours of the façade in the background, by the lances and rifles, the standard, the Captain's stick, and other elements. The back wall manifests some horizontal lines in its cornice, together with some vertical lines such as those on the right-hand side, where the wall projects, and to either side of the archway. Although these lines do not pass over the entire surface, they nevertheless create the impression of a grid of vertical and horizontal lines spread over the whole picture – yet one that is only intimated, since each individual line is constantly interrupted, is not sharply drawn, and can be distinguished only with difficulty against the dark surface. For this reason, it would be pushing things too far to speak here of a grid. The structure remains open, and does not bind the format together. Nonetheless, the lines bestow upon the surface a structure such as is consistent in itself, one presenting a distinct contrast to the diversity of direction to be seen in the other straight lines mentioned above. It is fascinating to notice how the spears leaning against the wall on the right, for example, diverge but minimally from the vertical lines of the ground – yet this divergence is sufficient to disperse the impression of a consistent "grid", or prevent its consolidation from the outset. A different orientation is adopted by the slanting lines, first of all that of the standard's stave, the direction of which is taken up by the Captain's stick and the rifle of the man in red in the left-hand foreground, and secondly, that of the almost vertical direction of the spear which the man in the helmet immediately above the Lieutenant is holding, in an upwards direction towards the right-hand border of the picture. Other straight lines would appear to go along with this second direction: the Lieutenant's lance, the gun with the muzzle flash, the flintlock whose pan is being blown out, and the pointing arm of the third figure from the right. The lines of the standard's stave and of the spear pointing to the right, if they are extended, lead to the head of the brightly illuminated girl, albeit barely intersecting at the top of the head's outline. Visible points of intersection are avoided here, in an almost methodical manner; however, they accumulate on the other side. Swords, rifles, and other spears cross the main axis mentioned above in different directions, while a star-shaped double overlapping may even be seen above the previously discussed pointing arm. Yet all this does not serve to make the brightly lit girl the centre of the main directions; equally, nor does the star-shape form offer a central point for the principle under which the lines are distributed. It is significant, moreover, that the "accompanying" axes mentioned above are not parallel – they are almost so, it is true, but no more than this. A structure of geometric relationships would seem to have been intended but not realized.

Into this structured system of straight lines is woven the chain of small roundish forms. This chain, which description cannot enable one to follow, is made up of the overlapping outlines of the figures; its indentations are such as could lead one to think distantly of a laurel garland. It crosses the whole width of the picture midway up, tending to confuse or break up any comprehensive

Titus at His Desk, 1655
Oil on canvas, 77 x 63 cm
Rotterdam, Museum Boymans-van Beuningen

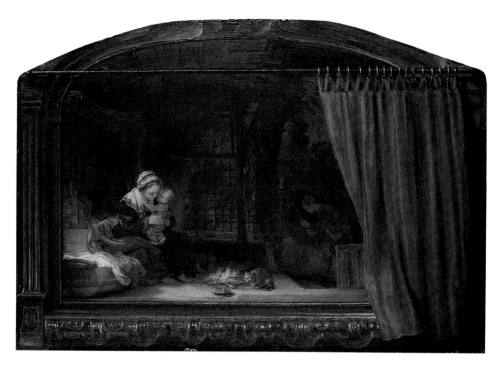

The Holy Family (with painted frame and curtain), 1646
Oil on oak panel, 46.5 x 68.8 cm
Cassel, Gemäldegalerie Alte Meister,
Staatliche Kunstsammlungen Kassel

efforts at orientation. This serves to focus the observer's gaze upon the light-dark structure in this zone, from the limits of which this feature emerges.

If one concentrates exclusively upon the smaller bright elements of this linear network – the impression can be heightened experimentally by blinking one's eyes – the heads and collars can be seen to follow one another in a garland leading first from the left in a curve down to the girls. From here, it continues upwards over the helmet adorned with oak leaves, passing in an upwardly curred arch over the heads of the Captain, the Lieutenant and the man behind them to that of the old man blowing into his powder pan. Finally, it rises over the remaining heads and the pointing arm to the right-hand border of the picture, from where it rolls on towards the centre of the picture as far as the drum. Another section of garland, not necessarily connected to the first, is formed from the heads of the figures in the archway. Notwithstanding the fact that all of the small details of the individual forms offset the tendency to recognize directions, it would be possible to speak from a very general point of view of a rough symmetry, in the sense of two wings unfolding towards the sides. The centre of this double form can be seen in the two most extensive and striking elements of illumination, those of the Lieutenant and the girl. The form of the Captain, which has been rendered extremely dark apart from his equally bright lace collar, would thereby be integrated into the symmetrical pattern and almost framed within the picture, this latter process separating him – it is said again and again, by a sort of rectangle – from the rest of the structure.

If one advances this view, however, then it is always necessary to emphasize immediately the opposite view, namely that it is in fact impossible to demonstrate a symmetrical shape in the light-dark structure. The bright areas constituted by the Lieutenant and the girl are of such differing size, the distance from them to the Captain is so unequal, that it is far from convincing to argue that they are symmetrical objects. As regards the smaller bright elements, they are of course related to each other, but the comparison with a connected garland overshoots the mark. At the same time, the structure can also be seen as a group of isolated elements, or divided up into sporadic, separate groups. There is no one single line constituting an order in which the bright elements – at least,

the faces – should be seen as connected. Several equally valid "paths" are available to the observer, along which he can follow the garland.

The openness and divergence of the light-dark structure is great, yet not so great that its tendency to form a unified arrangement could be denied. Rectangles, oval arches, spiral forms, left-right symmetry – in each case, the observer is pointed in the direction of a basic geometric order. Yet it cannot be grasped. The elements of spontaneity, motion, even disorder, assert themselves all the more, renewing the challenge to the observer to find a general system.

An important discovery with regard to the light-dark effect is made when one runs one's eyes – if possible at an even speed – over the described garland, for example from left to right across the whole picture. In this process, one becomes aware of an extremely differentiated succession of brighter and darker elements. The contrasts resulting from this alternation culminate in the central zone, dying down again towards the sides and finally reaching a provisional end at the half-bright drum, from where the next sequence of movement could then start. As the observer's gaze travels across the picture, the light-dark alternation is experienced as a free, sporadic rhythm, one in which the intensity, the size of the individual elements, and the intervals between them combine to produce a highly differentiated and particularly dynamic effect. At the same time, however, the sequence of alternation does not appear to be entirely free. The rhythm appears to follow an underlying beat, and it is only over this that its free dynamic can unfold. That which has been indicated here may serve to make clear that the entire observable structure of this picture reveals itself in detail with reference to the lines and the light-dark structure as arranged individually and in accordance with an open structure, yet tending towards a general formation in every part. Indeed, the pictorial structure of *The Night Watch* can itself be characterized as individual motion shortly before the establishment of order.

The purely visible qualities of the picture assert themselves here as a self-supporting system possessing its own drama and motion, independent of the recognizable qualities seen in that which can be comprehended within the scene. The same dramatic structure is revealed both in that which is readily apparent here and in that which can be understood via the portrayal in the scene. The change taking place that is signified by *The Night Watch* and the following collections of pictures within the course of Rembrandt's development is a step from interpretation to observation.

Christ at Emmaus, 1648
Oil on panel, 68 x 65 cm
Paris, Musée du Louvre

Observation as comprehension: The Staalmeesters

Rembrandt painted his last group portrait in the year 1662. In *The Staalmeesters* (p. 58) – the name given the board members of the Clothmakers' Guild – the artist would once again combine the achievements in the structural conception of his portrait scenes. After the so richly developed scene of *The Night Watch*, the later picture strikes the observer as a simplification; it appears to take up the earlier work of *The Anatomy Lesson by Nicolaes Tulp* and even – going beyond this painting – the group-portrait tradition of more than a hundred years, in which the persons to be portrayed are collected one after the other around a table, generally with a minor figure included. However, the picture with which we are concerned here surpasses its predecessors in density, complexity and fullness of life. Moreover, the superficial resemblance to the traditional forms reveals all the more clearly the fact that Rembrandt's crucial innovations consisted not in an external break with the forms which he had taken over but in their transformation. The portrait, as a document of someone existing in time, is intended to release that person from the bounds of time. It is the task of the representation to turn the observer's thoughts back to the subject of the portrait and thereby preserve the memory of him. In contrast to this, Rembrandt's structural conception converts the portrait so as to give it the qualities of a temporal event, thereby changing remembrance of the past into observation of the present. It is not his intention in his portraits to overcome the temporal nature of a person by using art to disconnect it from time, to immortalize it. Instead, he is on the way to overcoming the temporal through a form of anchoring it in time, one in which timeless eternity appears itself in the present. It is not his intention to extend the temporal, ephemeral element of man to everlasting duration; rather, he wishes to anchor in time the timeless element – that is, that which is independent of temporal restrictions – and thus to enable it to achieve a present that can be experienced. But what pictorial form must this take so that it may be experienced?

The members of the board are giving their report. The offices of those present are indicated by the open book on which Willem van Doeyenburg[4] has let his hand drop in explanation and in which the gentleman on his right has placed a hand, ready to turn to a certain page; by the treasurer's purse on the far right; and by the notebook by means of which the half-standing Volckert Jansz. is propping himself on the table, while Frans Hendricksz. Bel, the house supervisor, who is standing bareheaded in the background, serves to give an indication of their significance. Poses are no longer adopted here. The body language of the men reveals a complete obliviousness to the world around them, stemming from their preoccupation with what they are doing. The facial characteristics of the figures are finely differentiated, from expectant concentration direc-

The Standing Syndic (Study for The Staalmeesters), 1662
Pen, brush and bistre, 19.3 x 15.9 cm
Rotterdam, Museum Boymans-van Beuningen

The Syndics of the Clothmakers' Guild (The Staalmeesters), 1662
Oil on canvas, 191.5 x 279 cm
Amsterdam, Rijksmuseum

ted outwards, apparently connected with a readiness to intervene in what is happening, via an interested following of what is taking place, to a relaxed observation of the entire scene. Here, too, the expressions are made to speak. However, the attitudes of the men are not typical of the representative attitudes encountered at a board meeting, unlike the typical attitudes of those attending a lecture displayed in *The Anatomy Lesson by Nicolaes Tulp*, for example. The characteristic gestures are so nuanced and meaningful that their only sensible interpretation can be as an expression of that individual – and him alone – in whose face they are to be read. A key to the scene, however, is provided by the observation that it is within this very individualization that the persons act, not each for himself but collectively, simultaneously and equally.

Extremely economical allusions to perspective – the view from below of the table, the armchair, the panelling on the receding back wall, and – no less – that of the hat brims – make it apparent that the group is seated on a level above that of the artist. Assuming that the depicted situation is taking place in an assembly chamber, then it is only from a seat in the audience that the observer would so perceive the board members on the podium.

In *The Anatomy Lesson by Nicolaes Tulp*, the observer's gaze is met by those of two figures in the picture, inviting him to see himself as a fellow-protagonist. None of the figures in the scene of *The Staalmeesters* is looking at the observer. The three gentlemen seen above the area of the red table are indeed looking out of the picture; however, their gazes pass to the left of the observer. The man in the armchair to the left is also turning in that direction, while Volckert Jansz.'s eyes are directed towards a point to the observer's right. This makes it quite clear that the group is not only acting collectively but also reacting collectively, to a partner outside of the picture, to an audience. The fact that the figures are looking past the observer draws him into the scene to a far greater extent than was the case with the direct exchange of glances in *The Anatomy Lesson*. Quite unexpectedly, he finds himself a member of the large audience, this latter constituting the cause of the group's reaction. At the same time, it becomes clear that he is no active participant within this audience – in the sense that he does not put his hand up, give his vote when invited to do so, or maybe even interrupt the speaker. As a member of the audience, the observer is allocated the role of a witness, a spectator. In the earlier work depicting his mother as the reading *Prophetess Hannah* (p. 26), Rembrandt rendered the observer a potential participant to some extent by allowing him to look into the book. Henceforth, this motif is revealed to be a comprehensive and inescapable principle of Rembrandt's structural conception: in seeing – and grasping – the situation as portrayed in the scene of *The Staalmeesters*, the observer is already executing his observational role. The fact of his looking at the scene is itself already a pictorial motif, a part of the picture's action, whether he wishes this to be so or not.

However, whereas the effects resulting from the structural conception of the picture thus become comparable with real-life situations outside of the picture, the basic depictive problems of the portrayal of temporal actions become all the more critical. How does Rembrandt represent movement here? Volckert Jansz.'s posture has been interpreted in many different ways. In the preliminary sketch (p. 59), he is seen still standing upright. An X-ray of the picture reveals the fact that Rembrandt altered the posture a number of times while painting the picture. In the final version, he is shown neither sitting nor standing. One hand, holding the notebook, is propped on the table – as described above – while the other appears to be groping behind him, as if touching the armrest of a chair, or being on the point of doing so. This, together with the concentrated look directed outwards, can convey the impression that Volckert Jansz. is stand-

60

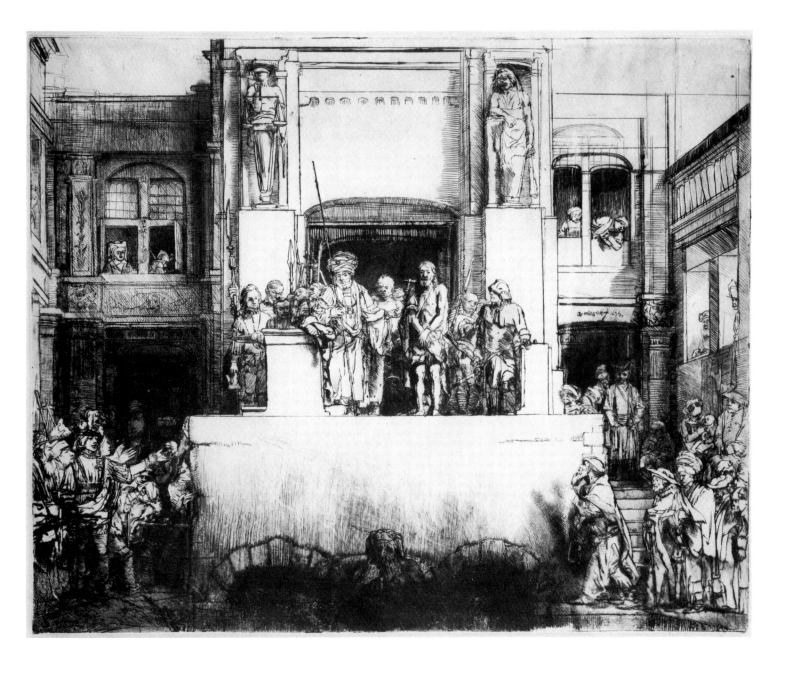

ing up to answer a question from the audience. On the other hand, he could also be on the point of sitting down after a speech. While the attention of the other board members is still or currently occupied by someone or something on the left, his gaze remains upon a member of the audience who – to give but one possible explanation – is not yet content with the answer which he has received and is making the fact known, as happens again and again in business discussions, while the debate is already moving on elsewhere. What is significant is the fact that the two interpretations given here totally contradict each other. The directions of movement mentioned are diametrically opposed to each other: one cannot simultaneously stand up and sit down. Nonetheless, Rembrandt's attempt to portray such a posture – as documented by the numerous alterations that he made – would appear to have taken the direction of just such a contradiction. A broad range of possibilities is to be found in the middle area of the course of events between standing up and sitting down. Volckert Jansz. stands up, but the situation changes rapidly; before he is upright, he hesitates in a half-erect posture: either he could straighten up, or he could take his seat again. Alternatively, he has been speaking on his feet and is about to sit down when an objection occurs; he pauses, could stand upright again and add a postscript to

Christ Shown to the People, 1655
Etching with drypoint, 7th state,
35.8 x 45.5 cm
Amsterdam, Rijksmuseum

61

his speech – or could complete the process of resuming his seat. It is also possible, having attained such a posture, to pause for a moment while taking note of a vote by the audience and deliberating whether an intervention is necessary or not. Rapid external movement, the lingering action of temporary duration, and the quietly continuing action, seen distributed among a number of persons in *The Blinding of Samson* - all three characteristics of action are encountered here in a single gesture. The motif of action within these particular limits is ambiguous.

Corresponding to this concept, the nature of the glances of the other board members is equally ambiguous. As shown here, their gazes can be understood as lingering, but also, if one looks at the picture in a different way, as fleeting glances moving over the audience. And even if they are interpreted as lingering glances, they can be subject to change through an increasing or decreasing degree of interest, in the progressive forms that have already been examined in the various possibilities of interpretation regarding Volckert Jansz.'s posture.

The ambiguity observed here should not be interpreted as indicating a lack of clarity; rather, it is purely functional. One need simply recall the fact that it is not until the observer uses his imagination to conjure up the various potential facets of the action that the corresponding qualities of movement or change come to light. The fact that the actions are brought before the observer should not be seen as representing a contradiction to the static nature of the picture; rather, the observer himself is challenged to actively complete the mental picture, to play a game. If he does not participate, then he cannot understand what is in front of him. This game consists of linking the various ambiguous elements. A structure of relationships brought about by actions develops, although its elements openly undergo change even in their various aspects. As a result, the structure becomes complex and many-layered, and can no longer be tied down to a single status. In the course of all this, the game of imagination itself acquires a certain progressive character. Within this progression, the observer experiences the to-and-fro motion of directions and impulses, the alternation of action and reaction. In so doing, he carries out an action the course of which is as changeable as is sometimes the case in a debate between two groups of people at a meeting. This also ultimately implies that the observer, in becoming aware of this, realizes himself to be already involved in this action, as it is in fact a question of his own conscious action.

However, such qualities of experience are not only dependent on the motifs of action of the figures. The spatial structure was only partially characterized above. Despite all certainty, it is in fact simultaneously completely open. The section seen in the field of vision presented to the observer gives no indication as to the distance from the observer to the figures. As a result of the lack of foreground, they give the impression of being observed as if from close to. At the same time, however, a different effect argues for their being seen from afar. The colours of the figures, the objects and the surroundings are uniformly broken in colour against a warm shade of brown. The impression arises that this common shade of refraction is not inherent in the colours but stems from a gloom illuminated by light, one such as appears when haze or smoke fills the otherwise clear medium of the air. The brightened gloom of the atmosphere – certainly intensified here beyond the empirical possibilities – can only be found *between* the coloured objects and the eye of the observer. It thus becomes impossible to exclude the observer from this spatial system, since this state of "between" only comes into being when one is face to face with the picture. If the observer understands the manner in which the objects and figures appear as an atmospheric effect, then he finds himself taken up into the atmosphere of the pictorial space

– in a manner that is just as inevitable as was the case with the scenic constellations. For the figures can only be seen in this way by an observer who can be said to share the atmospheric conditions of visibility experienced by the figures in the picture. Put another way, the objective manner in which the pictorial world is painted can only be seen if one is looking at it subjectively. This was noticed by Jacob Burckhardt: "Rembrandt is indifferent to the real structure of things; it is their appearance which is all-important for him ... as far as Rembrandt is concerned, events, forms, natural objects only exist inasmuch as air and light play their wondrous game with them."[5] However, it is not necessarily a question here of gaining an "undreamt-of magic" from the light, nor of mystically transfiguring the world. Previously, the act of observation itself appeared to be drawn into the scenic process; now, the observer cannot avoid being involved in this event in the pictorial world, also with respect to the manner in which the object world appears in the picture. The picture loses the character of something existing objectively for itself, inasmuch as the "depicted" act of seeing and that performed by the observer no longer occur independently of each other: for something to appear within the picture, it must be disclosed by an act of observation.

One final observation concerns the relationship of the scenic order to that of the picture itself. The positions of the individual figures, as surface elements, stand in a subtle relationship of interdependence with each other and with the background. Thus, the jamb of the chimney at the back frames the treasurer, while the position of the man on the armchair to the left receives clear confirmation through the projecting corner above him. The red table unites the three board members seated behind it. Volckert Jansz. stands out on account of his half-standing posture, which in turn is qualified by the higher position of the house supervisor. The two heads for their part render Willem van Doeyenburg a central element; and so on. The positions on the surface become isolated under the influence of one aspect and combine under the influence of the other; they simultaneously emphasize and qualify each other. A structure of relationships results, one appearing ever more complex, the further the observer pursues the

The Anatomy Lesson of Dr. Joan Deyman, c. 1656
Pen and bistre, 11 x 13.3 cm
Amsterdam, Rijksmuseum,
Rijksprentenkabinet

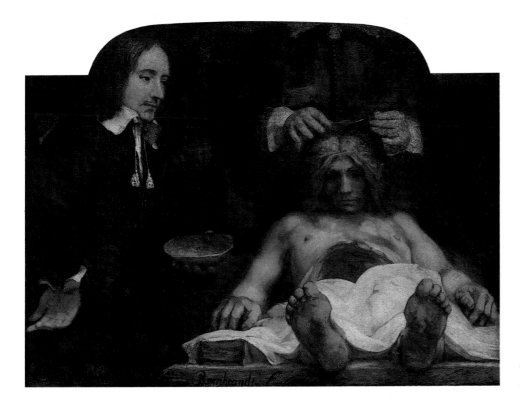

*The Anatomy Lesson of Dr. Joan Deyman
(Fragment),* 1656
Oil on canvas, 100 x 134 cm
Amsterdam, Rijksmuseum

interactions that are presented. The apparently so simple arrangement, one which seems so natural through its apparently arising from the chance element of a seating arrangement, enables the observer to see the forms at one and the same time as a number of isolated individuals and yet also as a group of differentiated people acting in unison.

The pictorial form of the portrait would appear to be no longer subject to the event being depicted. As has been seen, the interplay of relationships emerging from the change of aspects becomes itself a kind of action through the activity of the observer. Furthermore, the structure of this interplay corresponds to the event and contributes an additional nuance to the interpretation: the interaction of the individual areas of colour becomes a condition for the individual element to be shown to its advantage, each serving the other and defining itself via the others. It is difficult to describe this wealth of relations in words, but it perhaps has something to do with the kind of relationships among the persons, and between them and the audience.

This also serves to explain why it is that one does not grow aware of the purely visible pictorial values – the interplay of bright and dark areas, of red, yellow, white, black, and gold-brown – as a self-supporting system, as was the case in *The Night Watch* (pp. 50/51). The dramatic effects of the bright-dark structure have been reduced. Painting is no longer presented in terms of artistry and virtuosity. This is not to say that these are not to be found here: indeed, they are present to a high degree. In order to achieve the outlined effect of the atmospheric element, the execution of the painting must satisfy the highest demands in a technical respect as well. Rembrandt's style of painting has also become extremely individual. The qualities of his painting have lost any intrinsic value, are becoming discreet, and are absorbed into the service of the previously mentioned manner in which something appears. Rembrandt's path towards enabling the observer to experience that which is temporal through the picture is thus indicated: he forms the pictorial elements themselves in such a way that the observer can only become aware of them within the process of their appearing to him. This will ultimately be observed to comprise the realm in which the mystery of Rembrandt's art lies. In *The Staalmeesters* (p. 58), the appearance in the picture of the event's temporal structure would seem to have been approached, in the same way that the temporal action would appear to have been approached; with regard to the actions of the observer, this means that comprehension is brought closer to observation.

First of all, however, we should focus once again on the path leading to the final step, that in which the motifs of the action ultimately become one with their appearance. The artist's work on structural conception can be grasped all the better from his drawings, since this medium of itself means that the visual qualities fade in importance, to the benefit of the action portrayed.

The Sacrifice of Isaac, 1650
Pen and bistre, 18 x 15.5 cm
Dresden, Kupferstichkabinett,
Staatliche Kunstsammlungen Dresden

Abraham's Sacrifice, 1655
Etching and drypoint, only state,
15.6 x 13.1 cm
Vienna, Graphische Sammlung Albertina

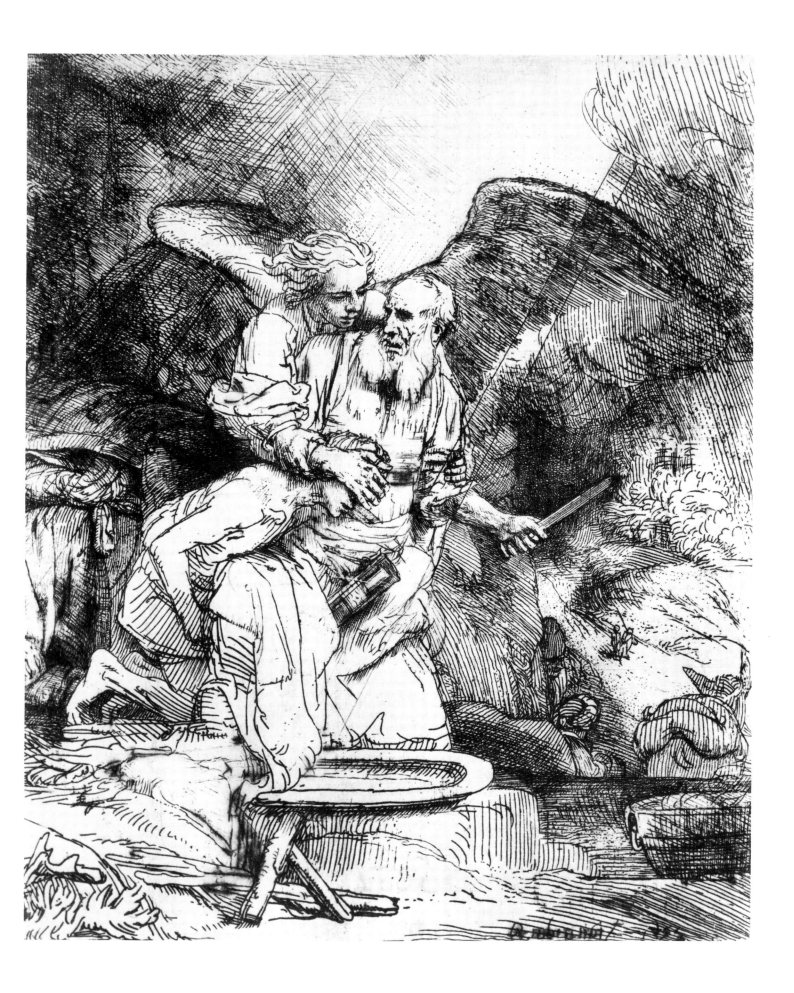

The search for life in the picture: Susanna and the Elders

An examination of the series of versions by Rembrandt of the subject *Susanna Surprised by the Elders* reveals that the artist did not have a clear conception in mind before starting work, that it was not simply a question of translating what was in his imagination into pictorial form. They show that Rembrandt, when working on his structural conception of the picture, orientated himself increasingly in the course of his creative work to the visual effect that it would have on the observer. It was no different in the developing stages of *The Staalmeesters*. Rembrandt could not plan the subtle nuances when visualizing a temporal event; they had to be searched for in the process of observation. The series of different solutions for a subject makes it possible for us to follow this search.

The apocryphal text in the Bible to the Book of Daniel tells of Joakim, a respected figure who possessed an expensive house with a garden during the captivity of Israel in Babylon, where the Jews customarily met. Among these were two elders, who performed their judicial functions there, and were passionately in love with Joakim's wife, the beautiful Susanna. One day, accordingly, when she was taking her bath in the garden, the two men pounced on her together: "Look! The garden doors are shut, and no one can see us. We are burning with desire for you, so consent and yield to us. If you refuse, we shall give evidence against you that there was a young man with you and that was why you sent your maids away. Susanna groaned and said: I see no way out. If I do this thing, the penalty is death; if I do not, you will have me at your mercy. Yet it is better to be at your mercy than to sin against the Lord." Susanna refuses, is slandered and sentenced to death. However, the elders are finally convicted as a result of the advice of a boy, who suggests that they be questioned separately. That boy is the young Daniel.

The first version of the Susanna subject (p. 69, bottom) takes as its starting point – as was the case with so many of Rembrandt's history pictures – a painting by his teacher, Lastman. The chalk drawing adopts the picture's large-scale overall structure, the grouping of figures and the important pieces of scenery: the castle in the background, the sphinx spouting water on which Susanna is sitting, the tree, and also – on the far right – the peacocks. With regard to the decisive structure of the incident, however, Rembrandt proceeds in a manner entirely free from that of his model.[6] And – unlike his model – Rembrandt consistently structures the scene as a dialogue scene. The gestures of the elders as they speak make the alternatives of the blackmail clear. The one on the right is luring her with his finger, while the one on the left, standing close to Susanna, is indicating the castle with his thumb. Susanna is turning her back on the elders. The enticer, presumably the spokesman, meets her dismissive look. Susanna has therefore already understood what he is saying, and has rejected the

Detail from picture reproduced opposite, with retouching

Susanna and the Elders, c. 1655
Reed pen and bistre, 17.7 x 12.7 cm
Berlin, Kupferstichkabinett,
Staatliche Museen Preußischer Kulturbesitz

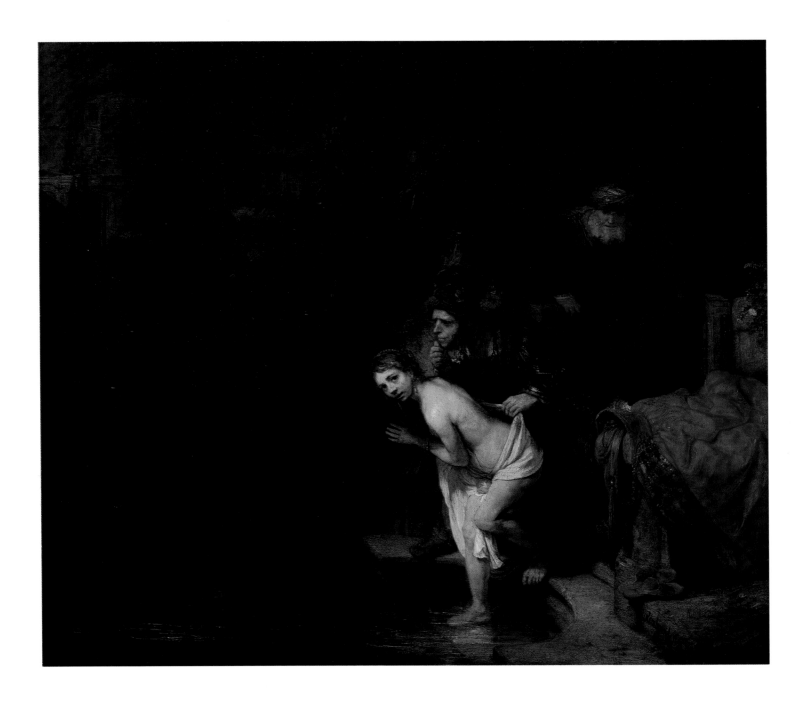

Susanna Surprised by the Elders, 1647
Oil on panel, 76.6 x 92.7 cm
Berlin, Gemäldegalerie,
Staatliche Museen Preußischer Kulturbesitz

notion. The speech is clear, but the manner in which the situation has come about, and the reason for his continuing with his speech after Susanna has made her decision, is not shown.

The second version (p. 69, top left) is restricted almost entirely to the three figures involved. The elders do not speak: they act. The one on the right is approaching; the one on the left is pointing to the castle with a sweeping movement of one hand while taking hold of Susanna with the other. Susanna is cringing away from them, no longer dismissive heroine, as before, but defenceless victim. The purely actional scene now portrays as deed what was formerly content of speech. The first scene could be termed "Susanna's refusal", this one "Susanna beset by the elders".

A brush sketch (p. 69, right) shows the third new conception, executed by Rembrandt in the Berlin painting (p. 68). For this reason, it is the painting which will be the subject of our attention here. The dialogue scene of the first version ran the danger of indeed showing a speech but not the suspense-filled drama of the incident; the second runs the danger of going beyond the dialogue, with every consequence for the contradictory nature of the movement

ILLUSTRATION, UPPER LEFT:
Susanna and the Elders, c. 1637/38
Pen drawing, 14.9 x 17.7 cm
Berlin, Kupferstichkabinett,
Staatliche Museen Preußischer Kulturbesitz

ILLUSTRATION, UPPER RIGHT:
Susanna and the Elders, c. 1641–44
Brush and bistre, 19.8 x 17.0 cm
Dresden, Kupferstichkabinett,
Staatliche Kunstsammlungen Dresden

Susanna and the Elders (Drawing after Lastman),
c. 1637
Red chalk, 23.5 x 36.4 cm
Berlin, Kupferstichkabinett,
Staatliche Museen Preußischer Kulturbesitz

69

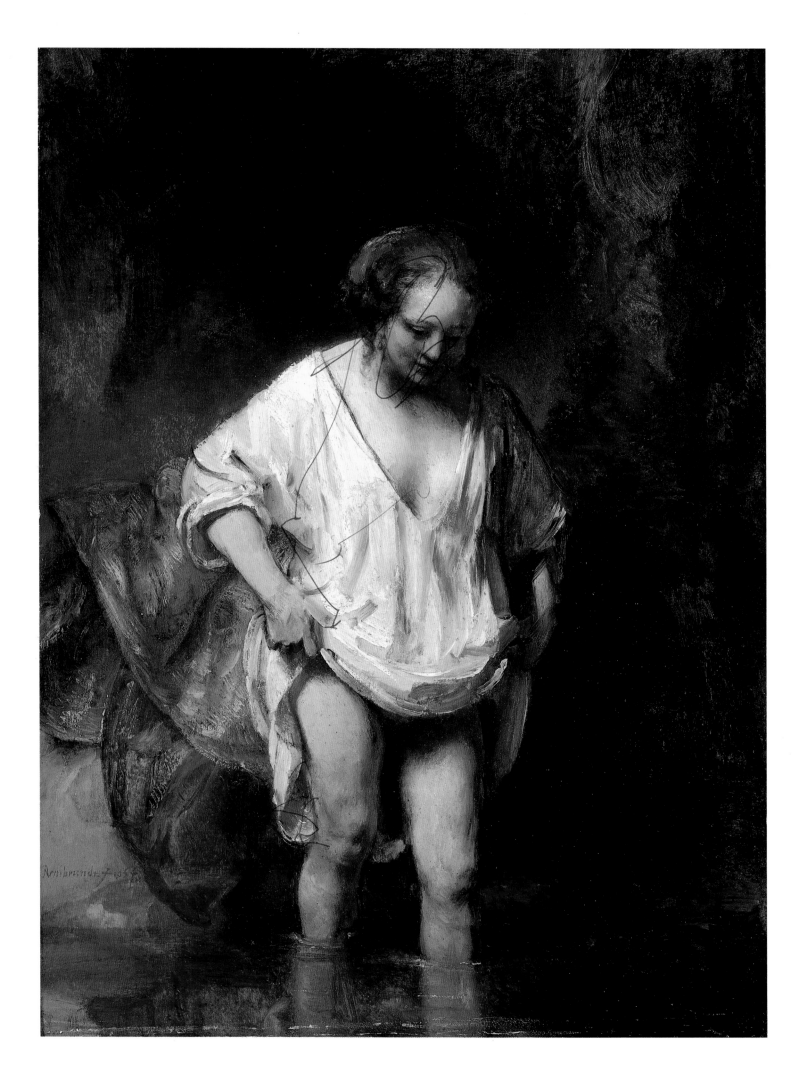

displayed in the picture. In comparison, the scene in the Berlin painting brings action and dialogue closer together. Only one of the elders has advanced as far as where Susanna is standing, watched by the other, who is pausing with his hand on the open garden gate. The former, standing in close proximity to Susanna, is staring at her as if awaiting an answer. His left hand, balled into a fist, is held under his chin; the upwards-pointing thumbtip still contains an allusion to the castle, albeit one that is considerably muted. He has grasped Susanna's cloth with the other hand: the alternatives of the blackmail are embodied by him alone. Rembrandt's exactitude becomes visible: in taking hold of Susanna's cloth, the elder has made his intentions clear; as yet, however, he has not touched Susanna herself. The scope of action given Susanna in the dialogue scene is returned to her, without the clarity of the action scene being lost. She is free to decide. She is standing bent forwards, one foot already in the water, the other still on the dry step down to the pool. She has lifted one hand, the fingers of which are slightly spread; with the other, she is attempting to hold together the loose cloth around her hips. Her face is shown in three-quarter profile. Her eyes are not concentrated on the same point: the right one is looking up towards the right, while the left one is directed out of the picture and meets the observer's gaze. Her mouth is slightly opened. As was seen with the figure of Volckert Jansz. in *The Staalmeesters*, her pose is ambiguous. Susanna is turning around, because she has been startled by the attack – or she is turning back to face the front and looking for a way of escape. Both possibilities allow her gaze fleetingly to meet that of the observer. The position of her feet is such as to enable her to continue into the water or to go back, or to remain for a moment where she is while she – third possibility – becomes conscious of her dilemma. This momentary pause, during which her eye, turned in upon herself, nevertheless falls upon the observer, marks the climax of the incident. However, this is no longer simultaneously the climax of the visible movement. Rather, her act of deciding is revealed in her lingering posture of temporary duration, and consequently signifies hardly any conflict with the static nature of the pictorial representation. It is in this light that her posture becomes an allusion to her inner activity: "Susanna, becoming aware of her dilemma, seeks a way of escape."

The last version is offered by a reed-pen drawing from the year 1655 (p. 66). The two elders have advanced close to Susanna – but from the left, and not, as previously, from the right. The scene is bordered on both sides by the suggestion of trees. The foreground is restricted through blocks indicating the edge and the steps of the pool. The castle towers over the scene and borders it to the rear, spreading across almost the entire surface of the picture. The enclosing wall of the pool is also presented head-on, like a barrier running across the whole width of the picture. Susanna's discarded clothing is lying there, indicated by means of an oblique S-shaped form with a vertical cluster of lines beneath it. Once again, one of the elders is pointing behind him with his thumb in the direction of the castle; the other, his fist under his chin and his other hand on Susanna's cloth, is standing on the steps of the pool. He would appear to be pushing Susanna from behind with his shoulder and elbow into the water, in which she is already standing up to her knees. She is bending forwards and holding her hands crossed, as if they were bound. Although it is impossible to be certain, it appears that she is holding her cloth in both hands. The Berlin painting, in depicting the one elder pausing at the garden gate, points not only to their entrance but also to the escape route kept open by the intruders against every eventuality. The later drawing reveals no such route. It is not shown how Susanna could have entered the water, nor is any space to be seen in which she could move. It could hardly be more readily apparent that she can move no far-

A Woman Sleeping (Hendrickje?), c. 1655/56
Brush and wash in bistre, 24.5 x 20.3 cm
London, The British Museum

Hendrickje Bathing in a River, 1654
Oil on panel, 61.8 x 47 cm
London, The National Gallery

ther, neither forwards nor backwards. None of the gestures points to rapid change. It is quite possible for them to continue as depicted. The gestures indicating the content of the words are also heavily reduced. The result of this is to considerably heighten the effect seen in the Berlin painting. Susanna is beset not just by one elder but by both of them at once. The rearward of the two would appear to be literally pushing the other forwards, to judge from the manner in which the latter is increasingly crowding Susanna, who has already been driven into the water. It looks as though the tender form must neutralize the pressure of the two massive figures. The variety of aspects, which led the observer to follow the actions of the figures in *The Staalmeesters* and the Berlin painting in the succession of the events, is revealed here as reduced, while the game of imagination appears stopped. However, this itself becomes an event: the absence of entrance and – more particularly – exit on a spatial level corresponds to that on the human level, since both literally and figuratively there is no way out. The recognition of a desperate situation was but one aspect among those offering potential explanations of Susanna's posture in the Berlin painting. Here, it represents the only explanation. In the Berlin work, one is made aware of the climax of the incident through a temporary break in the continuum of the sequence of other events. Here, the climax appears to be an everlasting present which has taken on duration: "Susanna in dire straits – Susanna confronted with a dilemma".

However, this dramatic element, executed in such a complex and nuanced manner despite the static nature of the figures, is hardest to comprehend, on account of the possibilities suggested by the figures' positions. It is impossible to describe the richly differentiated and lifelike effect without describing the pictorial figurations of the lines themselves. This was also the case with what has been said about the drawing up to now, although it was not noted at the time. If one attempts to describe Susanna's facial expression, for instance, then one becomes aware of the fact that it can hardly be discerned. It is not possible for a real-life physiognomy to be so fashioned. Her face falls into two completely different halves, each doing something else. However, should one include this among the usual cursory elements typical of a sketch, then one renounces the

River with Trees on its Embankment at Dusk,
c. 1654/55
Brush and bistre, No.5 in the Bonnat Album,
13.6 x 18.7 cm
Paris, Musée du Louvre, Cabinet des Dessins

possibility of naming those elements from which the dramatic impression of this drawing ensues.

Susanna's face is drawn as an oval (p. 67). The tip of her nose points sharply to the left. Her left eyebrow cuts the angle of her nose horizontally, while the vertical line indicating her eye, which is turned to the left, combines with her eyebrow to form another point in a leftwards direction. Her mouth consists of a double line, also pointing to the left. She is turning back. Her eyes encounter the face of the elder, startled, horrified, strongly demurring. On the right-hand side of the oval, however, her mouth opens out, ending in a roundish shape. Quite appropriately, her right eye consists of a roundish element drawn down towards the lower right, and floats relatively freely within the white and comparatively large surface of the oval. An upwards look is thereby suggested, one with no particular direction, open, defenceless, begging for help.

The same is true if one attempts to name the elements giving rise to the realization of the pressure exerted by the elders that weighs upon Susanna. It may be seen, if one looks from right to left, that the bulky outlines of the fig-

The so-called "Polish Rider" (attributed to Rembrandt), c. 1655
Oil on canvas, 116.8 x 134.9 cm
New York, The Frick Collection

ures' bodies, the enclosed areas of which are filled with many lines until they are solid, are inclined increasingly towards Susanna. A contrast is presented by the smaller, slimmer, linear shape without hatching that depicts Susanna, the appearance of which is consequently not heavy and which seems rather to be frail. As the lowest and last of the descending row, it is the role of the frail-looking linear shape to cushion the pronounced direction of the gaze coming from above. The result is an impression of pressure, without it being absolutely necessary to ascertain the details of the action from the figures. Thus it is that the character of the event becomes visible from Susanna's face, directly from the drawing's observable structural elements themselves, from angles, curves, and correspondingly placed points.

It is in this way that areas begin to take on dramatic effect which customarily remain unnoticed as staffage, background and trivia when one is concerned with understanding what is depicted. This enables one to notice all the more clearly what is taking place in the course of the observational act itself. In comparison with the figures, the sketched tree-shadow in the background reveals considerable hatching, the unrestrained effect of which is experienced not as something neutral but rather as representing an increasing threat. Something similar can be said about the distinct vertical lines which run from the cut-off tower in the top-right corner, via the tree trunk, down to the protruding edge of the square stone block at lower left. Continuous vertical lines generally create a calming and stabilizing effect. Here, however, the firmness of the vertical lines is weakened through their direction being broken up at a height parallel with Susanna's face by the horizontal parapet and the S-shaped twisting line indicating the bundle of clothes.

If these lines and their qualities are comprehended, then one can become conscious of the directions in which the observer's gaze can move. If his gaze follows the features of the rough hatching in the tree zone above Susanna, then the only possibility is for it to move back and forth in that same wildness. If it follows the vertical lines, then it takes a path corresponding in the up-and-down motion possible here to the borders of the field of the picture, here – for the first time – in vertical format. If it interrupts this vertical movement at Susanna's bundle of clothes and thereafter follows this twisted line, it is then led along a short stretch into an alternating to-and-fro motion. However, if the observer's gaze passes over the right-hand angles of the square stone blocks or the criss-cross lines of the lattice, any flow of movement is brought to a halt and becomes caught up in a static structure.

It appears that the drawing sets the observer's gaze in motion through a succession of movements, speeding these up or slowing them down and leading them in particular directions. As a result of this, the movement of his gaze itself receives a form, takes on a structural character. However, a movement which has a particular character should be termed *dynamic form*. The observer's gaze is transferred into a dynamic form, which is executed by the observer himself and shaped by the structure of that which is seen. The character of this dynamic form corresponds entirely to the depicted dramatic event. The constriction and hopelessness of the situation, the threat, the besetting and constantly increasing pressure upon Susanna, the to and fro of her dilemma – it is no longer necessary to deduce all this as a lasting present of interminable duration solely from the depicted facial expressions and gestures and the surroundings, for it is already discernible in the performance of the dynamic form of the observer's gaze, as stimulated by the purely visual formations of the drawing. Until now, the inner actions of the figures could only be seen from their postures, gestures and facial expressions; now, however, it is the observer who, through his own activity in

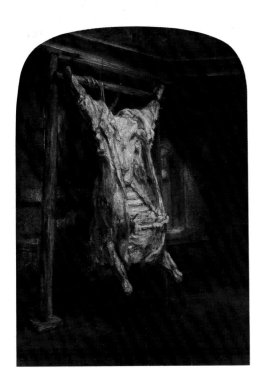

The Slaughtered Ox, 1655
Oil on panel, 94 x 69 cm
Paris, Musée du Louvre

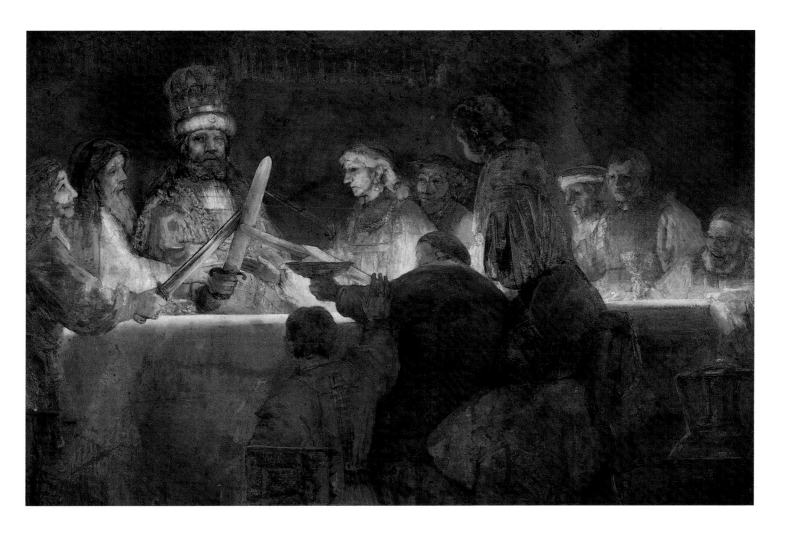

the shape of the dynamic form of his gaze, can experience the qualities of the dramatic process in the true sense of the word.

Let me demonstrate this once again with regard to the details seen in the drawing. It was not a facial expression which could be described with relation to Susanna's countenance but rather certain graphic qualities, the observational comprehension of which results in a dynamic form of defence on the one hand and one of abandonment on the other. This defence can already be seen as a structural gesture underlying Susanna's entire body-language in the first dialogue scene. Every point of an angle that is directed at a person creates the vivid impression of the path taken by a movement of refusal. Every bend downwards creates the impression of the course of a movement of heaviness and sadness. These elements are neutral of themselves; however, the process of observation makes their possible effects clearly visible.

The representation of external actions can never be completely realized in the picture, since it is necessary, if this is to happen, that the conclusion be reached via a process outside the picture. The same is true of the internal process of decision and that of searching for a way of escape in the Berlin version. In this painting, Susanna's activity could only be inferred from an interpretation of the posture of her body and from her face. Using his imagination, the observer must go beyond that which he sees in the picture. He cannot see her inner activity; he can only tell it from her face and posture. In the later drawing, he can rely entirely upon the picture without using his imagination, since its dramatic values arise directly from the pictorial experience.

The concern with turning a temporally dramatic event into a present such as could itself be experienced led Rembrandt to the limits of the possibilities

The Conspiracy of Claudius (or Julius) Civilis,
c. 1661/62
Oil on canvas, 196 x 309 cm
Stockholm, Nationalmuseum

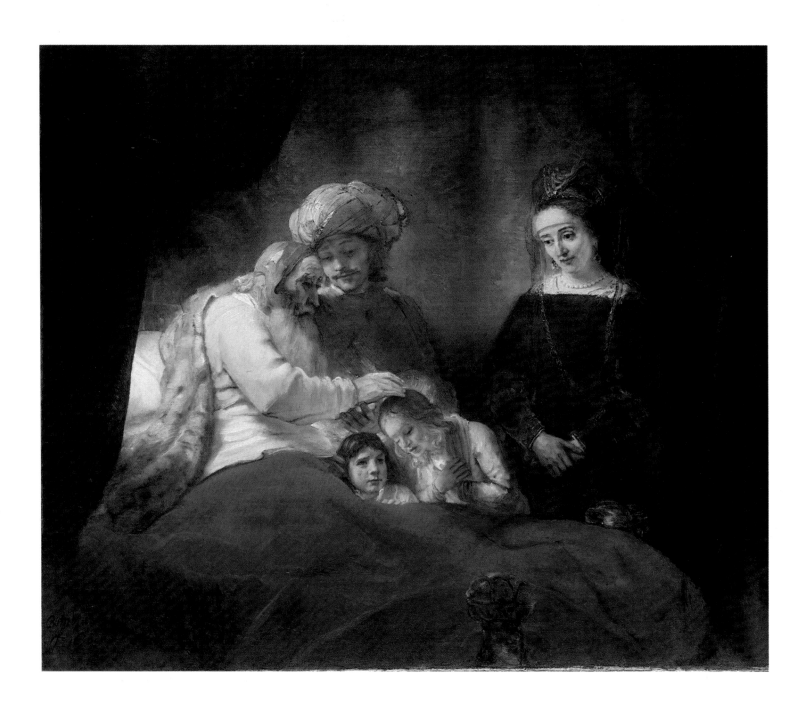

offered not so much by the picture, by artistic technique, as by the representation of reality in the picture. The important step, that which goes beyond every previous version, lies in the fact that the representation here no longer depicts that which is to be understood as action. As he looks, the observer can become conscious of the picture itself as a dramatic process. Rembrandt's search for precisely that form which raises such observation to the decisive factor brings the observer himself onto the path of never-ending observational experience.

A retrospective look at Rembrandt's work reveals the extent to which he remained true to his beginnings. The history paintings, the portraits, and also the few landscapes, are all structured as happenings, as events. However, this character of an event changes: it becomes illustrative itself. The path taken to reach this point has been described with reference to the drawing. Its lines may be experienced as a process, and thus lead the observational activity to the performance of particular characteristic dynamic forms, which correspond to the inner development of the happening. The later and final works reveal how the bright-dark factor and pictorial colour are also structured as such a temporary element. We are concerned here with an observation of the large compositions, such as *Jacob Blessing the Sons of Joseph* (p. 76), in which the scene takes on a quiet appearance as the old man gives his blessing. Reference should also be made to *The Conspiracy of Claudius* (or *Julius*) *Civilis* (p. 75), a fragment, the large conception of which reminds one of the many-figured scenes from Rembrandt's early days and middle period; here, however, the picture focusses completely upon the uniting act of the conspiracy. Finally, attention should be drawn to the last history painting, *The Return of the Prodigal Son*. The picture was completed by another artist. The moment has been selected in which everything taking place externally reaches its culmination in the son's devotion and the father's forgiveness. The entire series of late history paintings with one or two figures should be seen in this context, among them *Bathsheba with King David's Letter* (p. 2) and *Aristotle Contemplating a Bust of Homer* (p. 89). Bathsheba is musing over King David's letter summoning her to him, which has put her in the position of having to decide whether or not to commit adultery. Aristotle, likewise musing, has placed his hand on the bust of the blind poet. The picture of *Homer Dictating to a Scribe* (p. 86) portrays the consideration of words coming to mind – the gesture of his hand refers to a corresponding drawing (p. 87) – while four individual pictures of the Evangelists present variations upon this motif. The qualities achieved by the older Rembrandt in these and other works will be expounded here with respect to one painting, *Isaac and Rebecca* (*The Jewish Bride*) (pp. 80/81).

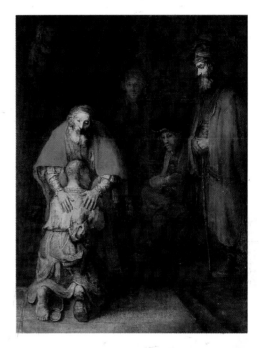

The Return of the Prodigal Son, c. 1666/69
Oil on canvas, 262 x 206 cm
St. Petersburg, Hermitage

Jacob Blessing the Sons of Joseph, 1656
Oil on canvas, 175 x 210.5 cm
Cassel, Gemäldegalerie Alte Meister,
Staatliche Kunstsammlungen Kassel

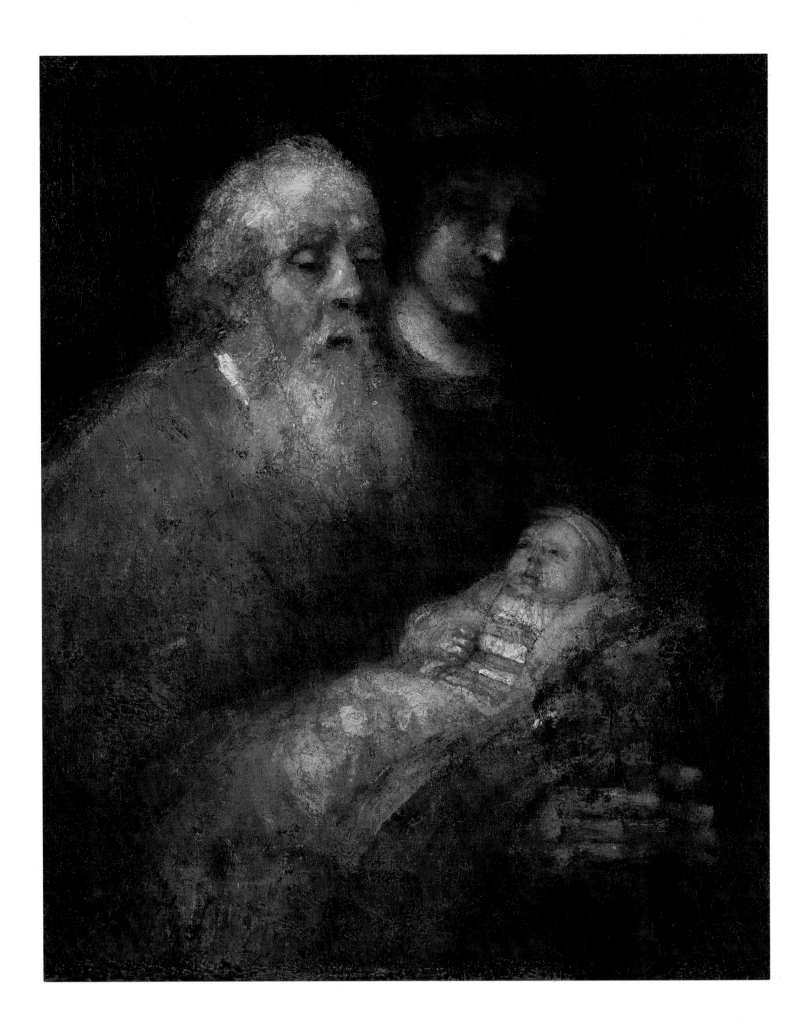

The mystery of the revealed form: The Jewish Bride

The picture of *Isaac and Rebecca (The Jewish Bride)* (pp. 80/81) has been the subject of many interpretations. The name *The Jewish Bride* refers to the long-held view that the picture portrayed the Jewish father of a bride bidding farewell to his daughter. A drawing by Rembrandt (p. 79) resulted in what has become the generally accepted description. This painting is also connected with a historical event, although it is restricted to the depiction of two people together. The only thing to remind the observer of the story is the masonry behind the embracing couple. This could be the well where King Abimelech eavesdropped on Isaac and Rebecca – yet this motif, which is still alluded to in the drawing, is absent here. The drawing shows the young woman on the man's lap. In the painting, however, the figures are merely close to one another, and it can hardly be ascertained whether they are sitting or standing. Isaac is bending towards Rebecca, has put one arm around her shoulders, and has laid his left hand – seen from the viewpoint of the observer – on her breast. The two are not looking at each other. Their gazes would appear to be turned inwards, reflective. With her right hand, Rebecca is touching Isaac's hand on her breast in a confirmatory manner. The drawing shows the same motif; here, however, Isaac is looking at Rebecca. The pictorial tradition has also handed down this motif in another narrative context. A drawing by Rembrandt depicts the Prodigal Son in a tavern, clutching the breast of a girl who is sitting on his lap. Rembrandt portrayed himself as *The Prodigal Son in the Tavern* (p. 47) in the Dresden painting, with Saskia on his lap. The self-portrait became generalized as a result of the role-playing. The faces and situation in *The Jewish Bride* produce such an individual effect that it is hard to imagine these faces coming into being without the use of models. It seems reasonable to suspect in the couple a portrait of Titus and his bride, Magdalena van Loo. Through its portrait character, the archetypal scene with the intimate couple takes on the binding force of an individual meeting.

The picture shows no external actions – not as movement. However, the posture of quiet duration involves a union in the embracing, touching gesture, a continuing activeness in the feeling of giving and receiving, in the growing awareness of a sense of togetherness. This activeness cannot contradict the quiet and static nature of the picture. Rather, quiet is the important condition here for experiencing the kind of incident revealed in this scene.

The description of the scene from *Susanna and the Elders* was concerned with the question of the effect upon the observer of the lines, which introduce him to the process of comprehending the picture. No such consistent graphic context or independent lineament is present in *The Jewish Bride*. Indeed, identifiable lines may be seen only in parts of the middle zone. It is only the contours of the faces, hands and arms, together with the bands making up the border at the

Isaac and Rebecca, with Abimelech Eavesdropping,
c.1655/56
Pen and bistre, 14.5 x 18.5 cm
New York, private collection

ILLUSTRATION PP. 80/81:
Isaac and Rebecca (The Jewish Bride), c. 1666
Oil on canvas, 121.5 x 166.5 cm
Amsterdam, Rijksmuseum

Simeon with the Christ Child in the Temple,
c. 1666–69
Oil on canvas, 98 x 79 cm
Stockholm, Nationalmuseum

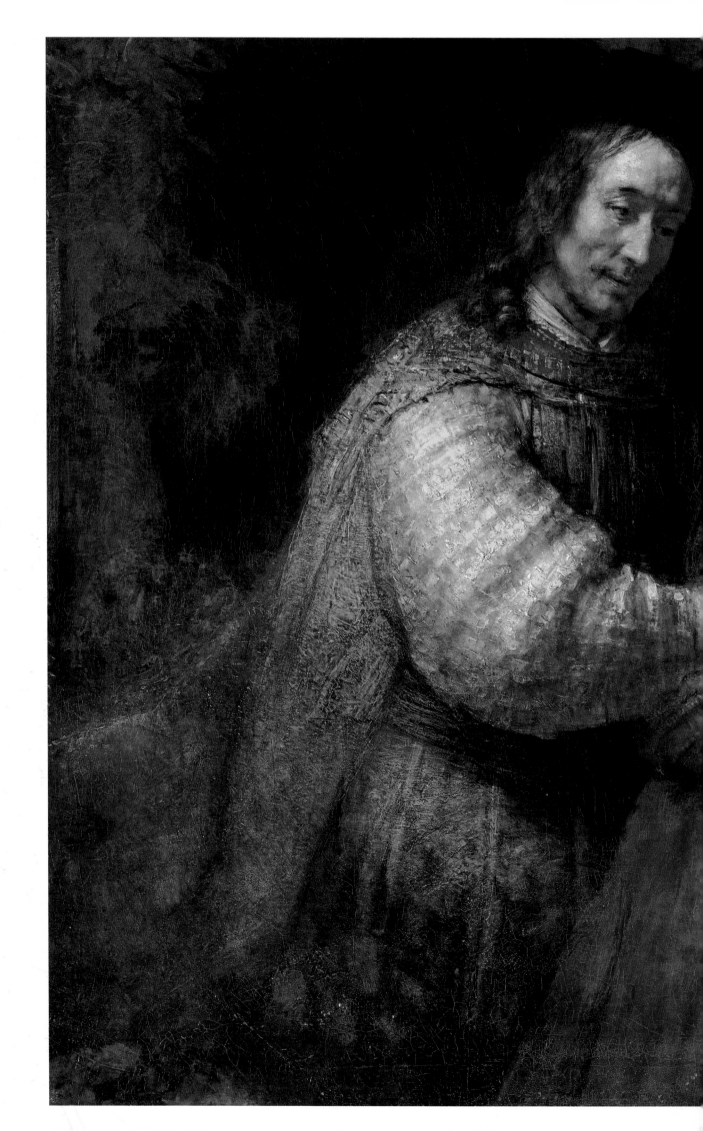

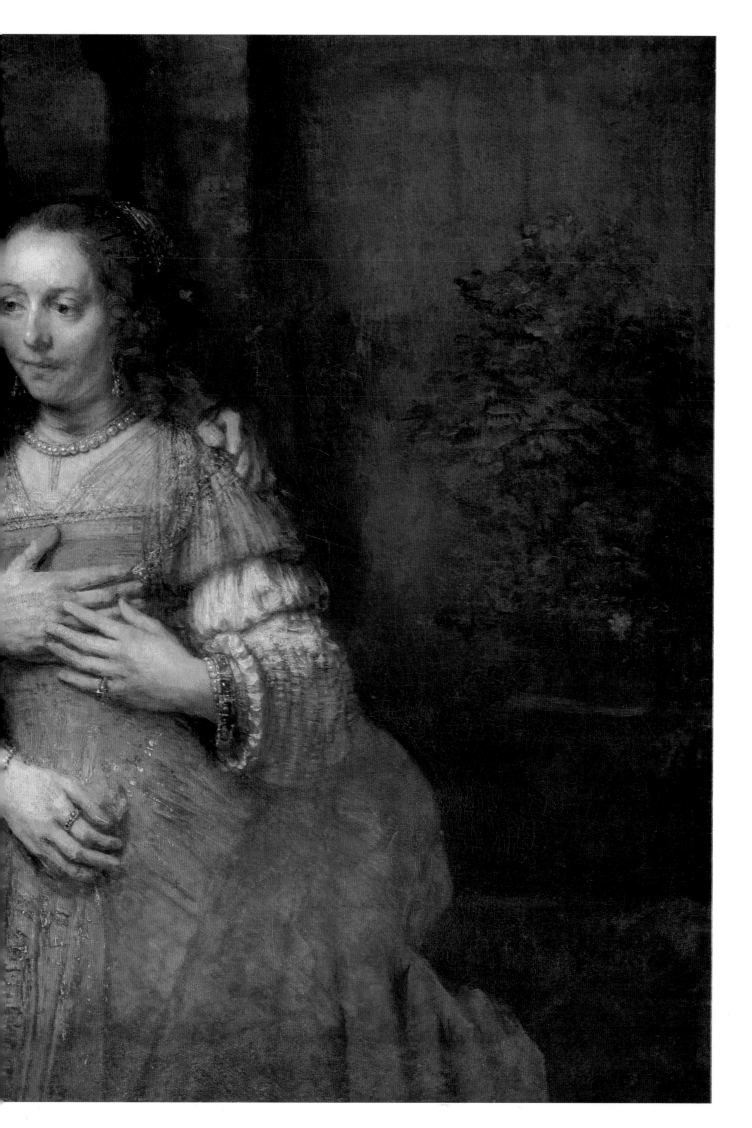

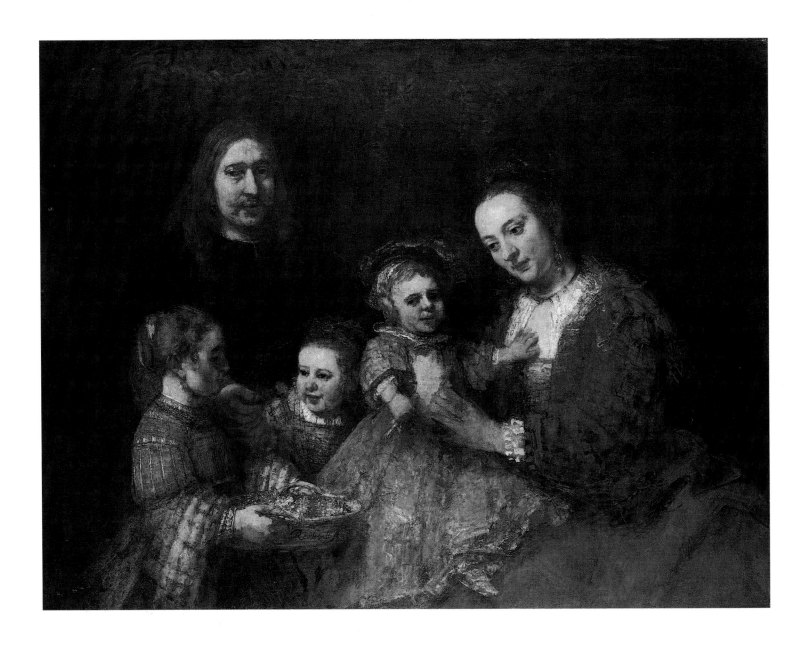

Family Group, c. 1668/69
Oil on canvas, 126 x 167 cm
Brunswick, Herzog Anton Ulrich-Museum

breast, which are defined by clear lines. However, the extent of these is not great. The clarity of the contours decreases to both sides of the group. Even the vertical lines in the wall of the well masonry, or the horizontal line at lower right, which could represent a stone bench, emerge merely as a narrow boundary zone between areas of differing brightness, and not as clear contours. (In examining the effect of the reproduction, it should be borne in mind that reduction has taken place.) If one pictures what is contained in the picture in the reverse direction, starting from the periphery and moving towards the centre, then an increasing clarity may be noted running along the contour of Isaac's cloak as it rises from left to right. However, the clarity of the lines remains relative, even in the central area of the picture; even in the case of the details mentioned above, they remain soft, transitory, merely somewhat denser than those widening out into the surrounding area and dissolving. The lines appear not as a structural means of its own but as the result of more or less distinct transitions within the coloured bright-dark area. They are clearest where the bright and dark zones present their greatest contrast. If the observer's gaze follows them from the periphery in an inwards direction, then they are perceived to thicken; seen from the inside moving outwards, they reveal a tendency to dissolve. In the same way that total delimitation is not found in the centre, how-

ever, total dissolution does not take place in the outer area. The observer's gaze is kept floating, and experiences – depending on the direction in which it moves – the tendencies of objects to become clearer or less differentiated, more concentrated or more diffused, to take on and lose form, as they merge with one another in smooth transformation.

An important element will be touched upon here but fleetingly: it is only when the central zone is covered up that one fully appreciates the intangible nature of objects in the surrounding area – it is no longer possible to give a concrete interpretation to anything, as far as the frame. Here, too, however, the effect of transference is at work, as observed earlier in the example of the shadow thrown by Captain Banning Cocq's hand in *The Night Watch*: one convincing detail causes the imagination to believe that it has seen the object at another place also, one where visual clues are lacking. From an objective point of view, it is impossible for a couple to stand or sit in the manner portrayed in the picture; similarly, no real lighting situation could result in such illumination. Nevertheless, the softness of the lines still gives a concrete impression inasmuch as it is understood as an atmospheric spatial effect – as seen earlier in *The Staalmeesters*. However, this exceeds every empirical comparison – with consequences that will be seen.

The observer's gaze is pushed in a certain direction and led in certain directions, not by individual lines, but rather by the broad, bright surface lengths of the couple's arms and hands, the contours of which could be seen as represented by the lines. Furthermore, attention should be drawn to the extent to which the rather isolated bright ovals constituting the faces tend to draw the observer's gaze and capture it, so that a faint resistance may become noticeable when the gaze is transferred from them in order to take in another surface element or follow the "lengths" described above. Two observations among many stand out here, which in turn simultaneously indicate the very individual structure of this picture's effect.

It has already been noted that the ovals of the couple's faces, among the brightest individual elements, draw and hold the observer's gaze. However, this can apply to only one of these elements at a time. If one attempts to keep one's eyes on one of the heads for a longer period of time, then it becomes noticeable that the force of attraction exerted by the other increases. The forms lie too closely together for the one to be seen apart from the other. If one accepts the attraction of the second oval, then a kind of jump occurs over the dark zone between the two faces – one of the darkest in the whole picture – the power of

Woman Lying down, 1658
Etching, drypoint and burin, 2nd state,
8.0 x 15.7 cm
Amsterdam, Rijksmuseum

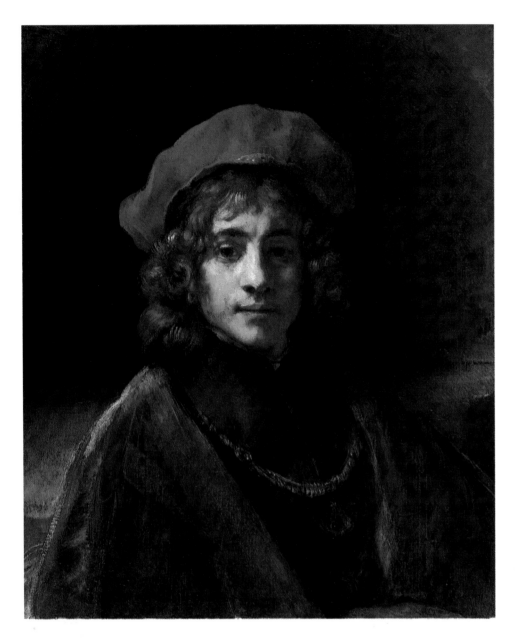

Titus, c. 1658
Oil on canvas, 67.3 x 55.2 cm
London, Wallace Collection, by kind
permission of the Curators

which to hold the observer's gaze is far less than that of the oval shapes. And for
the twinkling of an eye – in the truest sense of the word – the effect of the first
oval reasserts itself, so as to stimulate the eye into making the jump back again.
This interaction is weak, taking place neither rapidly nor with a rhythm that
can be grasped. It may be compared with a musical interval: if one attempts to
listen to one of the tones more clearly, then the other pervades the consciousness
all the more. The individual quality of the interval lies between the two, how-
ever – inaudible, yet in some way audible after all. The same is true of the pic-
ture: the relationship between the two bright ovals, perceived differentially in
this way, lies in the quality of the movement between them – simultaneously
visible and invisible.

However, the brightness of the faces is bound up with the other bright
forms to be found beneath them, so that the faces can each become the starting-
and end-point of a movement of observation, one which – seen from left to
right – leads over Isaac's shoulder and arm to Rebecca's breast, travelling from
there, over the border at her breast and the bright neckline, upwards to her
head. The approximately circular form that is passed through here does *not* close
at the top between their heads; the observer's gaze is prompted to retrace its
course, so as to take the same path once again. In contrast to the first observa-

tion, however, the gaze now takes in everything on and adjoining its path, and the possibility now exists for it of deviating from this course and climbing over Rebecca's hand as she has placed it on her breast to her right shoulder, thereafter gliding back down to the hands again along her right sleeve; from here, following this direction, it continues over the breast border until Isaac's right shoulder is reached, from whence the gaze flows back along the band of his cloak-fastening into the length of his arm; and so forth. The gaze's direction can join a pattern in the form of a reclining figure-eight, although this form is in no way a conclusively closed one.

If the observer's gaze moves in the direction outlined above, then it renders clearly visible the possible relationships among the individual visual elements in the picture. In this process, the movement of the gaze itself takes on the character of these relationships. The observational movements must be carried out by the observer, and are in this sense a subjective action. However, they take their form from the objective actuality of the visual elements within the picture. Subjective movement and objective shape penetrate each other, becoming a *dynamic form*. The picture thus speaks through the dynamic form executed by the observer. What precisely is spoken – if this is to be put into words, a different starting-point must be taken. The visual nuances indicated here would be misunderstood if one attempted to make them speak in all their variety and interrelationships. The character of the visual relationships in *The Jewish Bride* can

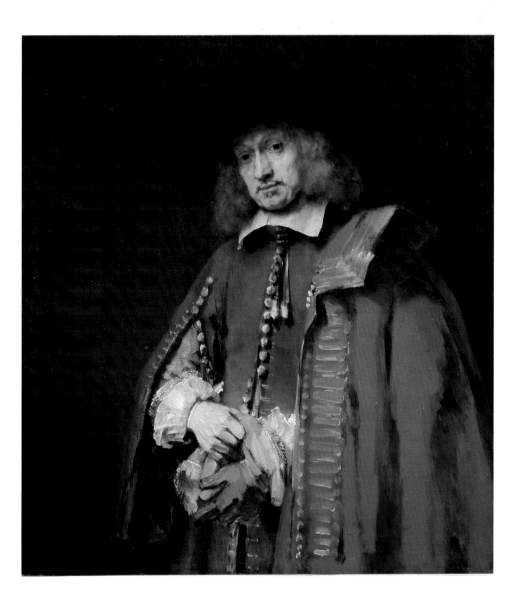

Jan Six, 1654
Oil on canvas, 112 x 102 cm
Amsterdam, Six Collection

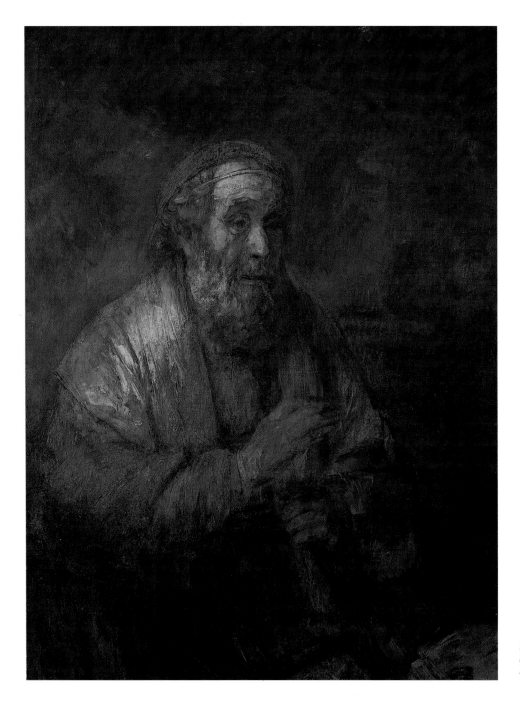

Homer, 1663
Oil on canvas, 108 x 82.4 cm
The Hague, Mauritshuis

only be alluded to via the interdependence between unity and duality: the
duality of the faces asserts itself in the previously described interdependent
dynamic forms of the observer's gaze between the bright fields of this otherwise
so unified double figure. In the case of the sequence of movements reminiscent
of a reclining figure-eight, it is those tendencies interlinking the duality of the
figures to form a unity which predominate. The purely visual dynamic forms
noted here reveal themselves to be the occasion for the immediate manifestation
of an inner structure, one consisting of the flowing together of two individuals
and a two-ness in unity. It is through the process of observation that the living
dynamic form of two who love each other takes place, the innermost and spon-
taneous expression of which is their embrace.

The strength of this picture, the factor responsible for its effect, may ulti-
mately be seen in the colours themselves. The red colour-tone of Rebecca's dress
– one example of the effects generally achieved through colour – is unusually
strongly broken, interspersed with dark brown – almost black – particles, but
also partially brightened through the use of yellow, and also of white in some

places. The fine, varnished texture, partly opaque in nature, partly shimmering through, reveals brush- and spatula-marks. When seen from a few paces away, this weave of colour merges before the observer's gaze, albeit without becoming completely uniform. From an objective point of view, the dark and bright parts could be interpreted as the play of light and shade among the fall of the folds of Rebecca's dress, and as the heaviness and softness of the material – as with velvet, for example, which does not fall smoothly and either shimmers in the light or allows one's gaze to sink somewhat into its surface. An objective interpretation must also take into account the effect described in the context of *The Staalmeesters*, that of the interplay of colours against a common shade of gold-brown, an effect caused by a brightened gloom between the objects and the eye. If this gloom were not also seen, the colour-tone would lead one to the superficial opinion that the dress appeared dirty or even decaying. The opposite is true, however: it creates a warm, velvet impression, as if glowing from within. This reddish tone is perceived, without one necessarily needing to be conscious of the fact, as if it were influenced by the three aforementioned factors – illumination, dress material, atmospheric gloom. A tacit assumption here is that the red of the dress material is uniform and – especially – that it is a property of this fabric. It is in this certainty, one that is not further called into question, that the fundamental agreement of depictive observation lies. This internalized bias implies that cause and effect in the relationship of colour and depicted object are reversed when one observes a depiction. The velvet dress, its illumination, and the visible atmosphere – none of these are themselves actually present in the picture; in consequence, none of them can be vehicles for the quality labelled "red". It is the red quality present in the picture – acting in combination with the other structural elements – that prompts the imagination to recognize the aforementioned objectivity. It is this red quality, exactly as it stands here before the observer's eyes and in no other way, that constitutes the vehicle that conveys to the imagination the concepts of dress, material, atmosphere, light. These properties reveal themselves in the representation as vehicles for the depicted object.

The establishment of this point may seem trivial. This, however, represents the starting point for the more complex question as to how it is at all possible to understand the true nature and quality of the colour here. Even if one disregards the question of reference to an object, then the colour still seems to have changed: when looked at from a distance, it can appear blotchy and nondescript. If one opens oneself up to the colour, however, then one perceives its shade as a pure, warm red glowing from within. In theory, it is impossible for a colour to manifest itself in a different way to its actual appearance: otherwise, we would be dealing with another colour. How can the impression emerge of this particular and consistent hue of colour? The shade of red which the observer sees as "the" red of the dress is not to be found in the pigment applied to the picture's surface – not even in small areas. This shade is seen, yet it does not exist. If a search is made in the colour structure for material evidence of this shade, then it vanishes in an indescribable variety of different nuances. In the course of this attempt to find it, the eye is struck by all those colours which differ from red – white, golden yellow, golden brown, dark brown, black – without the red disappearing completely. However, it is also possible at any time to discern the previously comprehended uniformity of the shade of red again. Nonetheless, this uniformity does not achieve an exposed, opaque red surface. Even when the red appears to glow from within, this is merely an approximation. The impression remains unstable. At any moment it can weaken, only to become stronger again a moment thereafter. As was mentioned above, the lines

Homer Dictating to a Scribe
Pen and bistre, brush, highlighting in white,
14.5 x 16.7 cm
Stockholm, Nationalmuseum

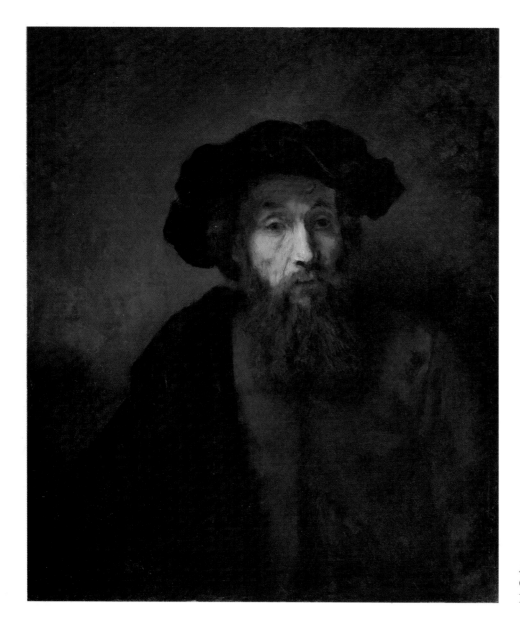

A Bearded Man in a Cap, c. 1657
Oil on canvas, 78 x 66.7 cm
London, The National Gallery

can be seen only as a system of qualified delimitation or dissolution, floating in a state between acquiring and losing form. It has now been seen that this is equally true of the colour in this picture. It must be comprehended not as a continued existence, one defined thus and in no other way, but rather as a tendency within the red effect towards or away from red, in a flowing, open intermediate state between concentration and diffusion, growing alternately brighter and darker, becoming present and withdrawing: in brief, a state between appearing and disappearing.

The consequence of this is that the visual effects of the picture's surface are perceived as something undergoing a process, one which is not fundamentally different from the movement perceived as the content of the picture.

In this way, the quality of appearance of the colour itself comes to play a role in the event, as the present effectiveness of light in colour. Light itself cannot be seen. Its effect can only be understood from the dynamics of colour. Light, as has been observed above, must be effective and active if it is to become a phenomenon. The same was said at the outset of these remarks regarding the actions of the figures. The effect of colour in the picture is revealed as the naturally invisible inner event: the warm, enveloping colours, together with their silent glow, seemingly intensifying from within, can display the same quality of feeling, in the form of a visual impression, as that which inwardly binds to-

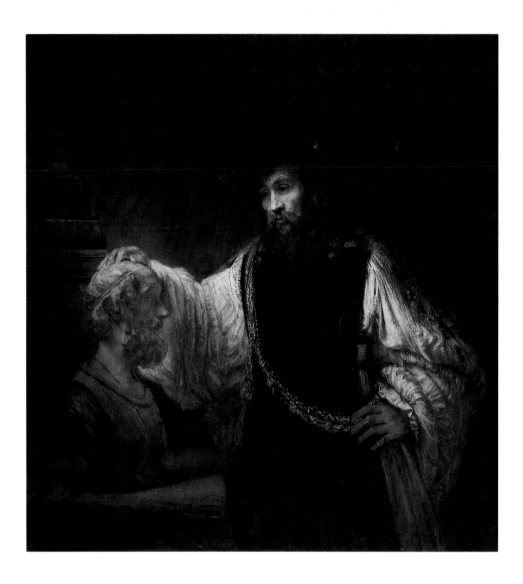

Aristotle Contemplating a Bust of Homer, 1653
Oil on canvas, 143.5 x 136.5 cm
New York, The Metropolitan Museum of Art

gether the two who love each other. If such words had not already been used, one could speak here of a glowing quality, of the appearance of something which has no effect upon the senses in a sensory experience. However, it is not claimed here that something is felt in either one particular way or another; rather, the view is advanced that such nuances of feeling are opened up through this kind of painting, not as a result of intellectual conclusions based upon that which the scene portrayed in a picture communicates, but rather through the process of observation itself.

If one accepts that effects, in the manner characterized here, are the chances of a picture, however, then the term "picture" can no longer be taken to mean only the object hanging on the wall, the merely sensory creation of colour and form before the observer's eyes. There would be as little sense in saying of this creation that it was changing or in motion as there would be in expecting a depicted movement to take place within it. The observable effect of the colours and forms only occurs and appears when the observer mobilizes his powers of observation and reason and enters into the game of possibilities offered by the work of art. This requires him to grasp the work of art, both with respect to its individual elements and in its entirety, and to combine them in accordance with the rules given by the picture. It is only in the light of such a conception of the picture's reality that there can be any sense in speaking of the appearance, the

Landscape, c. 1654
Pen and bistre, 12.9 x 28.4 cm
Stockholm, Nationalmuseum

process of events, the temporal quality of a painted picture, for without the observer this process will be impossible, in the same way that it is impossible in the absence of this particular work of art. The creation supplies the structure. It is given life in the act of observation, thereby – and only thereby – coming into existence.

As a result of his structural conception, Rembrandt allocates the observer a particular role, utilizing the later structural conception of *The Staalmeesters* to enable the observer, if he understands the context of the scene, to see himself as involved in the depicted process. This applies not only to that which may be understood from the picture but also to that which can be seen within it. Through Rembrandt's style of painting, the observer is assigned a constitutive role. In this manner of painting, one which causes the observer to appreciate the act of revelation instead of merely presenting him with a revealed form to look at, it is largely left to the discretion of the observer as to what he recognizes in the picture, since the aforementioned processes of observation are generally dependent upon his activating them. If he does not open himself up to these processes, then they will not become evident to him. The consequence will be that these pictures simply appear unfinished – the more so, the later their date of origin – for it is precisely in their leading the observer into a never-ending process of revelation that their completion lies. Nowadays, at the end of the 20th century, following the concrete experience of Modernist pictures, this never-ending quality of Rembrandt's art can make one conscious of the open, nascent, creative element present in the act of observation itself. The process of becoming aware of life in the picture, the process of becoming aware of the act of revelation, is an encounter with the productive powers of one's own observation. It is in the action of observation that the mystery of the revealed form lies to which we are led by Rembrandt's art.

Moses with the Tables of the Law, 1659
Oil on canvas, 168.5 x 136.5 cm
Berlin, Gemäldegalerie,
Staatliche Museen Preußischer Kulturbesitz

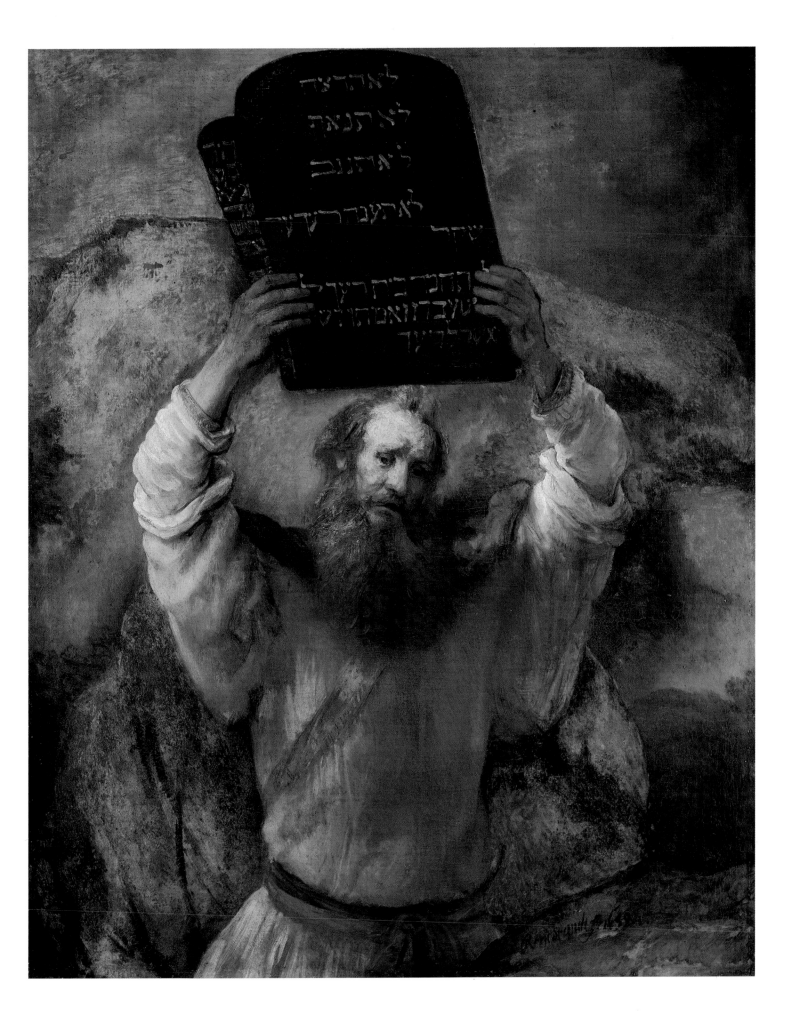

"Faust", c. 1652–53
Etching with drypoint and burin,
3rd state, 20.9 x 16.1 cm
Amsterdam, Rijksmuseum, Rijksprentenkabinet

Self-portrait, 1661
Oil on canvas, 114 x 94 cm
London, English Heritage, Kenwood House

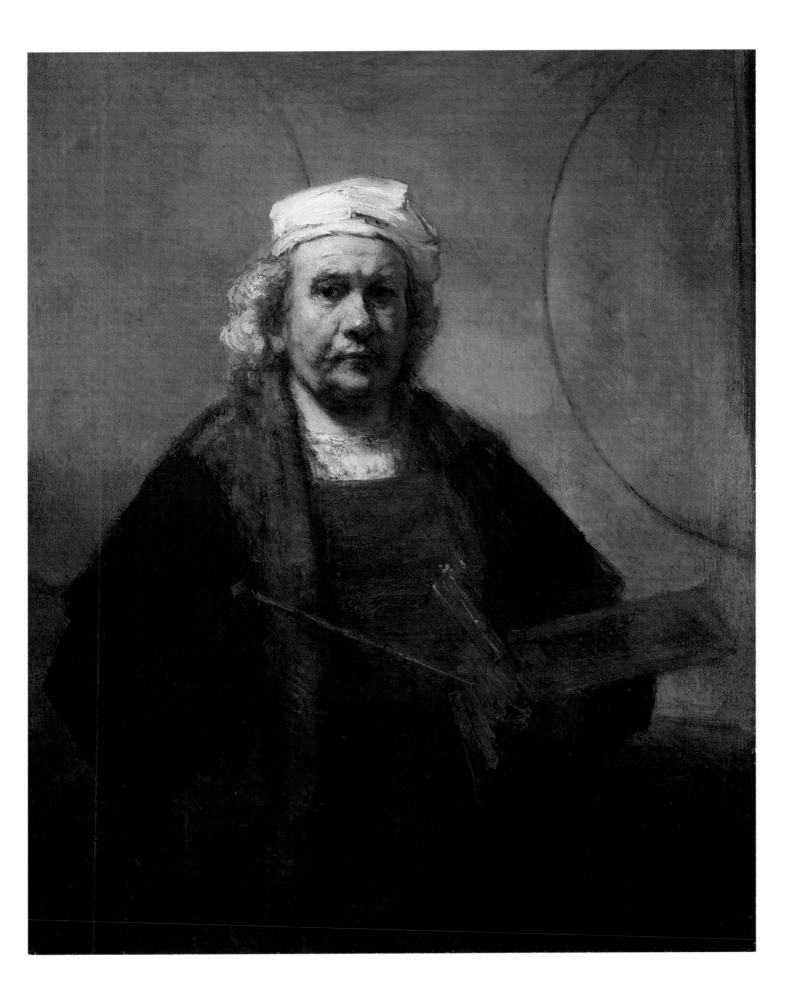

Rembrandt Harmenszoon van Rijn 1606–1669: Chronology

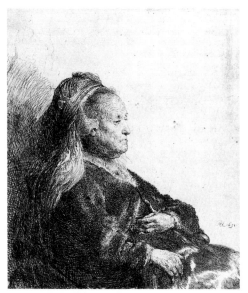

Rembrandt's Mother, 1631
Etching, 1st state, 14.5 x 12.9 cm

1606 Rembrandt Harmensz. van Rijn born on 15th July in Leiden, the eighth of nine children to Neeltje van Suijttbroeck and her husband, Harmen Gerritsz. van Rijn.

1613–1620 Rembrandt's parents, having had all his brothers trained as craftsmen, send him alone to the school for Latin. After seven years' schooling, Rembrandt enrols in the Philosophical Faculty of Leiden University to study Classics.

Leiden University 1614
Copperplate etching, 1641

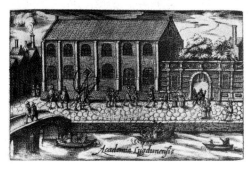

1622–1624 He abandons his studies after a short time, starting a period of instruction under the Italy-trained painter Jacob Isaacsz. van Swanenburgh. However, he is influenced to a considerably greater extent by the succeeding apprenticeship of six months under Pieter Lastman, the Amsterdam artist of history paintings.

1625–1628 Return to Leiden and foundation of his own studio in conjunction with Jan Lievens. Rembrandt produces history paintings, initially following Lastman's models; in addition, he executes physiognomical studies, resulting in numerous self-portraits, together with engravings and etchings, for which Callot's engravings partly provide the inspiration.

1628 Constantijn Huygens, the widely educated secretary of the governor, Prince Frederik Hendrick, comes to Leiden, and develops great interest in Rembrandt and his art.

1629–1630 Huygens' patronage leads to commissions and initial successes, as two works by Rembrandt are purchased by the English Crown and many copies of his paintings *Judas Returning the Thirty Pieces of Silver* and *The Raising of Lazarus* are soon to be found.

1630 His father dies on 27th April.

1631 Inspired by his initial success and drawn by the up-and-coming capital, Rembrandt moves to Amsterdam, where he lives in the house of Uylenburgh, the art-dealer, in the Breestraat, soon making a name for himself as a portrait painter of well-to-do Amsterdam patricians.

1632 Thanks to Huygens' mediation, Prince Frederik Hendrick acquires a number of paintings and commissions the Passion cycle. In addition, Rembrandt receives the commission to paint a portrait of Dr. Nicolaes Tulp, the surgeon, which he completes before the year's end. A total of thirty paintings result in the course of this year.

1634 Rembrandt marries Saskia van Uylenburgh, niece of the Amsterdam art-dealer and daughter of a wealthy patrician, on 2nd July. He becomes a member of the Guild of St.Luke, in order that he may train pupils and apprentices as a self-employed master. The names of eight of the pupils working in his studio are still famous today, among them Ferdinand Bol and Govert Flinck.

1635 Baptism on 15th December of Rembrandt's first son, Rumbertus, who dies after only a few months. Work on the paintings *Samson Threatening his Father-in-law, The Abduction of Ganymede* and *The Sacrifice of Isaac.*

1636 The Van Rijns move into the Nieuwe Doelenstraat, where Rembrandt begins to deal in works of art and start an encyclopaedic collection of exotic items, scientific and historical objects, and animals and plants. He paints *The Feast of Belshazzar, The Blinding of Samson* and, in the course of the following years, a series of portraits depicting Saskia, among them the double portrait *The Prodigal Son in the Tavern.*

1638 After Saskia's relations accuse her of squandering money, Rembrandt initiates legal proceedings. Baptism of their first daughter, bearing the name Cornelia; she, too, dies after a short time.

1639 On 5th January Rembrandt purchases a new house in the Breestraat, undertaking to pay it off within five to six years. Completion of the fifth and last picture for the Passion cycle.

1640 Baptism on 29th July of their second daughter named Cornelia, who likewise dies shortly afterwards; Rembrandt's mother dies one month later. He begins to paint landscapes and to engrave.

1641 Baptism on 22nd September of their son Titus.

1642 Following the completion of *The Night Watch*, Saskia's death, on 14th June, results in a caesura and crisis in Rembrandt's life. So as to relieve the widowed father, Geertge Dircx and – in the summer of the same year – Hendrickje Stoffels join the household. Rembrandt commences work on his most famous etching, the *100 Guilder Print*. His graphic works are met with ever-increasing popularity and are frequently copied and reproduced in engravings, especially for altarpieces.

1649 Geertge quarrels repeatedly with Rembrandt, and finally takes him to court on the grounds of an unfulfilled promise of marriage. Hendrickje testifies against the plaintiff. Geertge is sentenced to several years in the prison at Gouda.

1652 Antonio Ruffo, the Sicilian patron, awards Rembrandt the commission for the painting *Aristotle Contemplating a Bust of Homer*; it is completed in the following year.

1653 Despite numerous commissions, the fees from pupils and the proceeds from etchings, Rembrandt's debts are such as to compel him to continue to borrow money.

1654 Hendrickje is summoned before the Amsterdam Council of the Reformed Church, which reprimands her for immoral cohabitation with Rembrandt. The third daughter to bear the name Cornelia is baptized on 30th October.

1656 The title of the house is transferred to Titus' name on 17th May. Shortly thereafter, Rembrandt is declared bankrupt.

1657–1658 Rembrandt's house and collections are auctioned; however, the sum thereby raised is insufficient to cover his debts. He moves into the Roozengracht, where he leads a secluded life along with Mennonite and Jewish friends. Louys Crayers becomes Titus' guardian; after a long court case, he is successful in his attempt to have the boy's part of the inheritance returned to him from his bankrupt father's estate.

1660 Titus and Hendrickje employ Rembrandt in their art shop. Despite leading a secluded existence, he maintains many contacts. He continues to keep pupils occupied and execute commissions, such as the portrait of the board members of the Amsterdam Clothmakers' Guild, *The Staalmeesters*, which he completes in 1662.

1661 Antonio Ruffo purchases the painting of *Alexander the Great* and commissions a portrait of Homer.

1663 Death of Hendrickje.

1665 Titus reaches majority and receives his inheritance. Rembrandt is occupied with *The Jewish Bride*.

1668 Titus marries Magdalena van Loo on 10th February, but dies half a year later and is buried on 7th September.

1669 Rembrandt now lives at the house of his daughter-in-law, and becomes godfather to his first granddaughter on 22nd March. He dies on 4th October, without having completed the painting *Simeon with the Christ Child in the Temple*.

An Artist in His Studio, c. 1629
Panel, 25.1 x 31.9 cm
Boston, Museum of Fine Arts

Notes

Bibliography

1 Haak 1969, p. 81. Cf. also Tümpel 1977, p. 56

2 Cf. Tümpel 1986, p. 221

3 Tümpel

4 Schwartz 1987, p. 336 with list of names

5 Burckhardt 1984, p. 387

6 Cf. in this context Imdahl 1975, and Bockemühl 1985, p. 108ff.

The particulars of the etchings illustrated here (apart from B. 320, B. 34 and B. 76) follow Ludwig Münz, Rembrandt's Etchings, Vols. I–II, London 1952

Photographic Acknowledgements

The publishers would like to express their gratitude to the owners of the various pictures as listed in the legends to the pictures for entrusting us with the reproduction models and for permission to reproduce the works in question. In addition, the following persons and institutions also made reproduction models available to us:
© Photo R.M.N.: pp. 2, 30 top, 57, 72, 74. Peissenberg, Artothek: pp. 8 right, 18, 32, 33. Cologne, Rheinisches Bildarchiv: p. 11. Caluire, Studio Basset: p. 14. New York, Art Resource: p. 17. Berlin, Bildarchiv Preußischer Kulturbesitz, Jörg P. Anders: pp. 20, 25, 41, 45, 66, 68, 69 left, 91. Hamburg, Elke Walford: p. 21. Museumsphoto B. P. Keiser: pp. 37, 82. Dresden, Sächsische Landesbibliothek, Abt. Deutsche Fotothek: p. 45. Jeremy Marks, Woodmansterne Limited: p. 54. Archiv des Verlages: pp. 7, 16, 77, 79, 94.

Biographical works:

Tümpel, Christian: Rembrandt in Selbstzeugnissen und Bilddokumenten, ed. Kurt Kusenberg, Reinbek bei Hamburg 1977

An expanded version of the above, including a catalogue of the paintings and a comprehensive bibliography:

Tümpel, Christian: Rembrandt. Mythos und Methode, Königstein im Taunus 1986

Individual details regarding the artist's life, those commissioning works, portrait subjects etc., and a catalogue:

Gerson, Horst: Rembrandt. Gemälde, Gütersloh 1969

Haak, Bob: Rembrandt. Sein Leben, sein Werk, seine Zeit, New York/Cologne 1969

Schwartz, Gary: Rembrandt. Sämtliche Gemälde in Farbe. Aus dem Englischen von Andreas Schulz, Christina Callori-Gehlsen, Stuttgart/Zürich 1987

Works discussing the position reached by contemporary research and offering a comprehensive documentation of the paintings:

Stichting Foundation Rembrandt Research Project (RRP): A Corpus of Rembrandt Paintings, eds. J. Bruyn, B. Haak, S. H. Levie, P. J. J. van Thiel and E. van de Wetering, The Hague/Boston/London. (Published to date: Vol. I 1982, Vol. II 1988, Vol. III 1989)

Studies of the artist's style:

Bockemühl, Michael: Rembrandt. Zum Wandel des Bildes und seiner Anschauung im Spätwerk, Mittenwald 1981

Burckhardt, Jacob: Die Kunst der Betrachtung: Aufsätze und Vorträge zur bildenden Kunst, ed. Henning Ritter, Cologne 1984. (Chapter on Rembrandt 1984, pp. 384–405)

Hetzer, Theodor: Rubens und Rembrandt. Schriften Theodor Hetzers, ed. Gertrude Berthold, Vol. 5, Mittenwald/Stuttgart 1984

Imdahl, Max: Regie und Struktur in den letzten Gruppenbildnissen von Rembrandt und Frans Hals. In: Festschrift für Max Wegener, Münster 1962, pp. 119–126

Riegl, Alois: Das holländische Gruppenporträt, Vienna² 1927

Works examining specific questions:

Held, Julius: Das gesprochene Wort bei Rembrandt. In: Neue Beiträge zur Rembrandt-Forschung, eds. Otto v. Simson and Jan Kelch, Berlin 1973, pp. 111–129

Imdahl, Max: Wandel durch Nachahmung. Rembrandts Zeichnung nach Lastmans "Susanna im Bade". In: Konstanzer Universitätsreden No. 77, ed. G. Hess, Konstanz 1975

Simmel, Georg: Rembrandt. Ein kunstphilosophischer Versuch, Leipzig² 1919

A consideration of the fundamental method of approach behind the present work:

Bockemühl, Michael: Die Wirklichkeit des Bildes. Bildrezeption als Bildproduktion. Rothko, Newman, Rembrandt, Raphael, Stuttgart 1985